ABERDEEN
IN
50
BUILDINGS

JACK GILLON

AMBERLEY

First published 2018

Amberley Publishing, The Hill, Stroud
Gloucestershire gl5 4EP

www.amberley-books.com

British Library Cataloguing in Publication Data.
A catalogue record for this book is available from the British Library.

ISBN 978 1 4456 7616 6 (print)
ISBN 978 1 4456 7617 3 (ebook)

Origination by Amberley Publishing.
Printed in Great Britain.

Contents

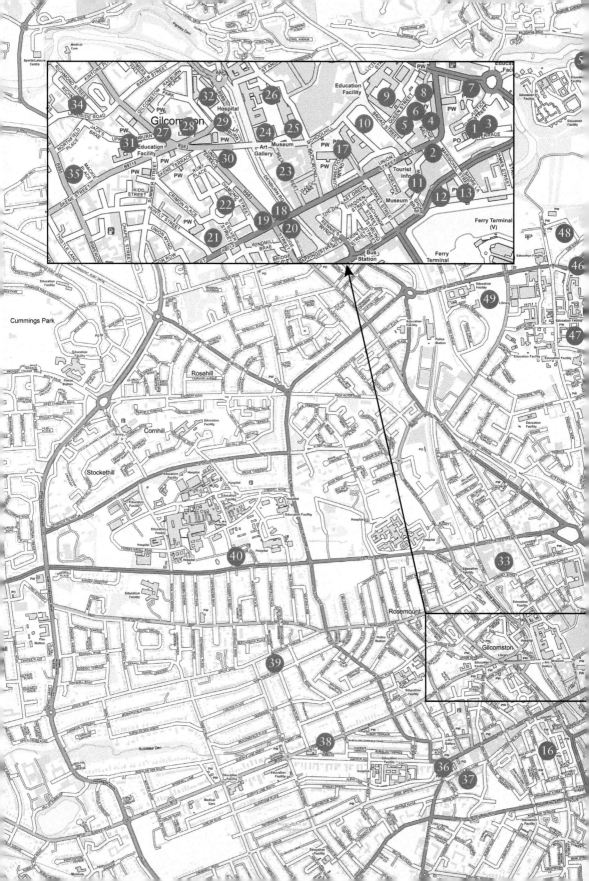

Key

1. Mercat Cross, Castle Street
2. Castlegate Well
3. The Salvation Army Citadel, Castle Street
4. Former North of Scotland/Clydesdale Bank, Castle Street/King Street
5. Town House and Tolbooth
6. The Former Medico-Chirurgical Society, King Street
7. St Andrew's Cathedral, King Street
8. Aberdeen Arts Centre, Former North Parish Church, King Street
9. Marischal College
10. Provost Skene's House, Flourmill Lane
11. Provost Ross's House and Aberdeen Maritime Museum, Shiprow
12. Harbour Office, Regent Quay
13. Former Custom House, Regent Quay
14. The Tivoli Theatre of Varieties, Guild Street
15. Aberdeen Railway Station, Guild Street and Union Square
16. Former Aberdeen General Post Office, Crown Street
17. St Nicholas Church, Union Street
18. Union Bridge
19. Former Northern Assurance Building: The Monkey House, Union Street
20. The Former Trinity Hall, Union Street
21. The Music Hall, Union Street
22. Golden Square and Duke of Gordon Statue
23. Former Triple Kirks, Schoolhill and Belmont Street
24. Aberdeen War Memorial and the Cowdray Hall
25. Aberdeen Art Gallery and Former Gray's School of Art
26. Robert Gordon's College, Schoolhill
27. Aberdeen Public Library, Rosemount Viaduct
28. St Mark's Church, Rosemount Viaduct
29. His Majesty's Theatre, Rosemount Viaduct
30. Wallace Statue, Rosemount Viaduct
31. Tenement Block, Rosemount Viaduct/Skene Street
32. Former Woolmanhill Hospital
33. Former Broadford Works, Maberly Street
34. Rosemount Square
35. Aberdeen Grammar School and Byron Statue, Skene Street and Esslemont Avenue
36. Former Christ's College, Alford Place
37. Bon Accord Baths, Justice Mill Lane
38. Queen's Cross UF Church, Carden Place and Albyn Place
39. Hamilton Place Villas
40. The Maggie's Centre
41. Footdee (Fittie)
42. Marine Operations Centre Harbour Masters' Tower, Pocra Quay
43. Torry Point Battery
44. Girdleness Lighthouse, Greyhope Road
45. The Beach Ballroom
46. Town House, Old Aberdeen
47. King's College Chapel
48. St Machar's Church, The Channory
49. The Sir Duncan Rice Library, Aberdeen University Library
50. The Brig o' Balgownie

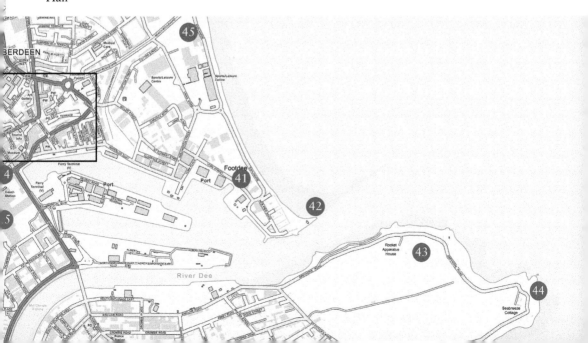

Introduction

Aberdeen has all the appearance, and is furnished with most of the attributes, of a wealthy metropolis. It has all the public buildings which distinguish a capital. The streets possess the proper degree of regularity and elegance. It has busy crowds, in which the stranger soon loses himself; and its inhabitants, when inspected individually, are found to possess the dignity, the wealth, and the enlightened views, which are never to be found but in towered cities.

The visitor enters the city by a long, spacious, straight, and regular way, denominated Union Street, which, when completed to the utmost of its designed extent, must turn out decidedly the finest thing of the kind in the kingdom. Previously to the opening of this way in 1811, the town was entered by a series of narrow tortuous streets.

The most remarkable thing about Aberdeen in the eye of a traveller, is the stone with which it is built. This is a grey granite, of great hardness, found in inexhaustible profusion in the neighbourhood, and of which vast quantities, fashioned into small blocks, are annually exported to London, for the paving of streets. Though not polished, but merely hewn into moderate smoothness, this forms a beautiful wall, of a somewhat sombre colour it is true, but yet strikingly elegant.

Aberdeen is a flourishing port, and is the seat of a set of active and prosperous merchants. It is the place where commerce first took its rise in Scotland. Having thus got the start by many centuries of every other commercial city, it has maintained all along to the present time a certain degree of advance; it is certain that in no other place is the mercantile science so thoroughly understood, or the commercial character carried to a pitch of such exquisite perfection.

The Picture of Scotland, Robert Chambers, 1828

Aberdeen from Balnagask.

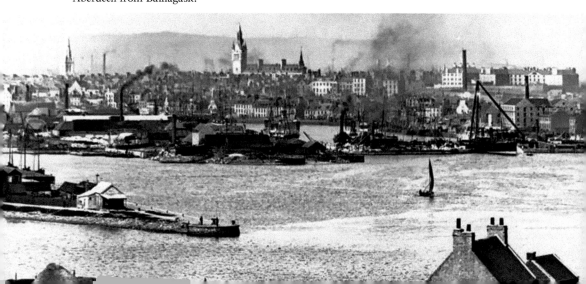

Aberdeen originally developed around St Katherine's Hill, a prominence that stood in the middle of the present-day Union Street. The town was given royal burgh status in the twelfth century and the Castlegate, or Marketgate, was the historic heart of the medieval burgh. The harbour was fundamental to Aberdeen's prosperity and the town's economic importance.

The rapid growth of Aberdeen in the eighteenth century resulted in its expansion beyond the tightly confined medieval streets around the base of St Katherine's Hill. A number of new streets were formed during this period of planned expansion.

In 1794, Aberdeen town council requested the engineer Charles Abercrombie to provide plans to rationalise the muddle of old unplanned streets of an increasingly wealthy and self-assured Aberdeen to connect the town to the surrounding countryside. Abercrombie's bold plan proposed a significant Georgian rebuilding of the city with two major new thoroughfares – one running westwards from the Castlegate to the Denburn, and the other north. An Act passed on 14 April 1800 approved the construction of the new streets – the road to the west became Union Street and the road to the north was King Street. These new roads represented major engineering enterprises and set the context of modern Aberdeen. Union Street was a particularly challenging project – the street had to cut through St Katherine's Hill, required a series of arches and a bridge over the Denburn. The generous scale of Union Street allowed the construction of buildings of substantial size and importance, and established Union Street as Aberdeen's main thoroughfare. The street was named to commemorate the union of Great Britain and Ireland, in 1801. John Smith (1781–1852), Aberdeen's City Architect, and Archibald Simpson (1790–1847) were the leading architects involved in this great remodelling of the expanding city.

Cutting granite at Rubislaw Quarry.

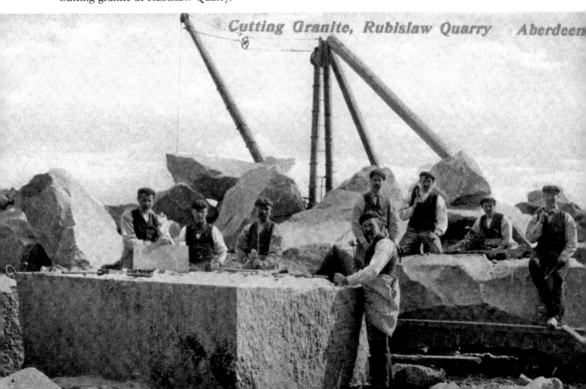

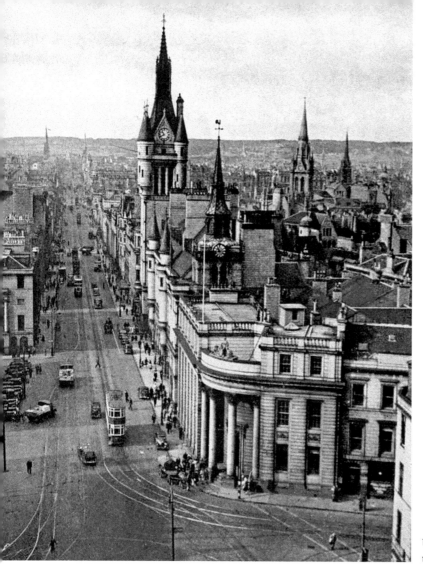

Union Street from the Citadel.

The predominant use of locally quarried grey granite up to the mid-twentieth century is a distinguishing feature of many of the city's most important buildings, which gives them a distinct glitter in the sun and earned Aberdeen the sobriquet of the 'Granite City'. The quality of the Aberdeenshire granite was internationally recognised and it was used for buildings around the world. The excavation of granite from the quarry at Rubislaw, which opened in 1740 and closed in 1971, created the biggest man-made hole in Europe.

Aberdeen is a thriving city which has been synonymous with oil ever since the discovery of North Sea reserves in the 1970s. It has a proud and distinctive identity, a wealth of fine heritage buildings and more recent developments of outstanding quality. This has made the task of selecting fifty buildings to represent the best of the city's architecture immensely difficult. This book takes the development of this rich and vibrant city as its broad theme, and includes buildings which seem to best represent the city's long history.

The 50 Buildings

1. Mercat Cross, Castle Street

At the termination of Union Street, is a fine oblong square, denominated Castle Street, with a beautiful old market cross at one end, and various public buildings around; this being the centre and cynosure of the city. Castle Street is the pride, the glory, the boast, the apple of the eye of Aberdeen. It is, indeed, a very fine place. The houses which compose it are old, and tall, and impressive; the town-house on the north side, with its adjuncts of court-house, &c. and its fine spire, is a dignified city-like object; the cross, with its stone entablature and its graceful column pointing to the sky, is an admirable thing, and not less valuable for its rarity than its beauty. Add to all these considerations that of its being the central point of half a dozen capital streets, and the merits of Castle Street will be complete and acknowledged.

The Picture of Scotland, Robert Chambers, 1828

The Cross and Exchange are situated opposite to the town-house. The first is a stone building, twenty-one yards in circumference at top, and seventeen feet high in the walls, which project a little for about four feet downwards. Under this circular projection, the wall has mock arches and pilasters, from which rise a row of handsome Ionic columns, on an Attic base. It is arched at the top three feet nine inches lower than the side walls. From the centre springs a Corinthian column twelve feet six inches high, which has a unicorn-rampant at top. John Montgomery, a country mason, was the architect of this work, which he built in the year 1686, and for which he received a hundred pounds sterling. This erection is neither useful nor ornamental. The exchange is a pavement of granite, squared and smoothed, eighty four feet in length, and fifty seven in breadth, raised two steps above the street, and terminated on the east by the cross. This piece of pavement was laid by order of the magistrates, in the year 1751 and it was formerly the general place of resort for the gentlemen of the town; but it has long ceased to be a rendezvous for the genteeler people, and is now principally occupied by sailors and soldiers.

History of Aberdeen, Walter Thom, 1811

The Aberdeen Mercat Cross dates from 1686 and was built by the mason John Montgomery of Old Rayne. It was originally located at the west end of the Castlegate, nearer the Tolbooth. It replaced the earlier High or Flesh Cross and the Fish Cross, which stood on the site of the existing cross. It was repaired in 1821 and moved to its present site in 1842. The original column was replaced in 1995–96.

It is a particularly notable example of an early mercat cross and marks the historic centre of Aberdeen. Mercat crosses were a symbol of a town's right to hold a market – an

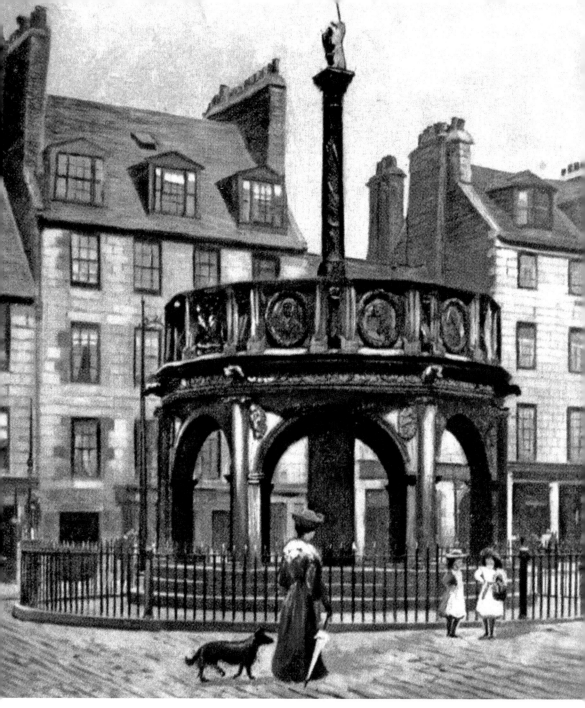

The Mercat Cross.

important privilege. It was where proclamations were made and public punishments carried out. A staircase led from ground level to the platform at the top, where announcements were made. The Old Pretender was declared king at the Mercat Cross on 20 September 1715.

At one time, there were four merchant's stalls inside the cross, which may account for Walter Thom's dismissal of it, in 1811, as 'neither useful nor ornamental'. The work to

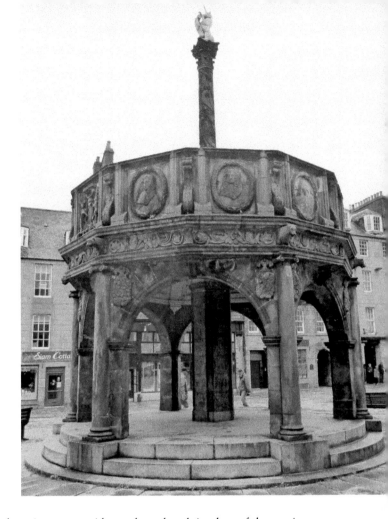

The Mercat Cross today.

the Cross in 1821 included alterations to provide one large booth in place of the previous smaller ones. For a time, in 1822, the arcade was filled in and it was used as the post office – the arches were reopened in 1842, when it was moved to its present site.

The Mercat Cross is 6 metres (21 feet) in diameter and 5 metres (18 feet) high. It stands on an open-arched hexagonal base with a central carved column decorated with thistles and roses, surmounted by a Corinthian capital and a white marble royal unicorn with a gilded horn (the shaft and unicorn are replacements from the mid-1990s; the originals are on display in the Tolbooth). The structure is splendidly decorated with animal gargoyles and royal portrait medallions illustrating the Scottish Stuart monarchs, the royal arms and the burgh arms. Lord Cockburn wrote in 1841 that he thought this was the 'finest thing of its kind in Scotland'.

2. Castlegate Well

The Castlegate Well dates from around 1706 and was an important first source of piped water to the town. It is known as the 'Mannie' from the sculpted lead figure that surmounts the sandstone base. In 1852, it was moved from its original location at the east of the Castlegate to the Green and, in 1972, it was moved to its present location.

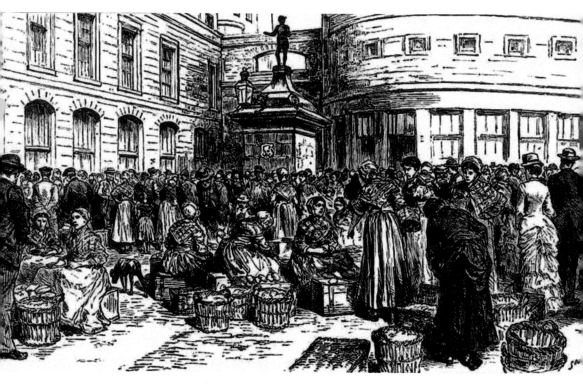

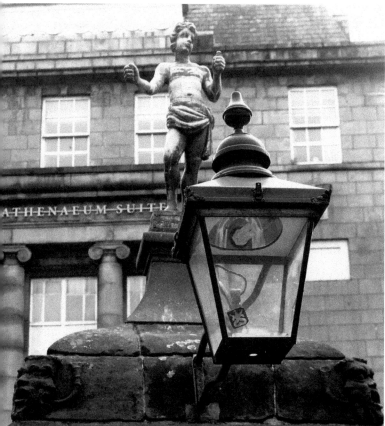

Above: The Butter Fare at the Green with the Mannie o' the Well.

Left: The Mannie o' the Well.

3. The Salvation Army Citadel, Castle Street

The Citadel is situated at the east end of Castle Street, where it fills the entire space from Justice Street to Castle Terrace. It has a frontage to Castle Street of 150 feet, to Justice Terrace of 110 feet, and to Castle Terrace of 106 feet. Looked at from Union Street, the new building has an imposing appearance. It is built of Kemnay granite, and is in the Scotch Baronial style of architecture. It is 62 feet from the ground level to the embattled parapet of the walls and, from the middle of the front, as seen from Union Street, there rises a massive and boldly-designed tower to a height of 150 feet. The ground floors in Castle Street and Justice Street are utilised as shops. The hall for the use of the army occupies the main part of the upper floors facing Castle Street. It is a large apartment, capable of accommodating 1,500 persons. The tower is, of course, the main architectural feature. On three corners, it is finished with small circular turrets with ornamental finials, but on the north-west corner there is a large turret rising a considerable height above the others and finished with an embattled course upon the walls. From this point perhaps the finest view of the city and surroundings is got.

The Aberdeen Journal, 20 June 1896

The massive Salvation Army Citadel occupies a commanding situation on the east side of the Castlegate. The foundation stone of the Citadel was laid by the Earl and Countess of Aberdeen, accompanied by General Booth, on 9 August 1863. The building was opened on

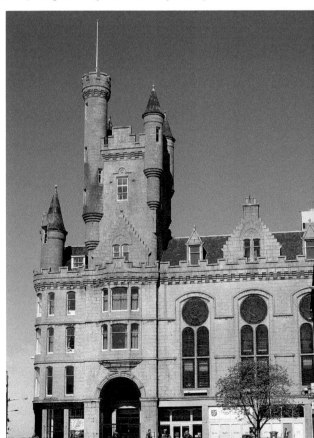

The Citadel.

21 June 1896 by the Salvations Army's Commissioner Coombs. The event was made 'the occasion of a great demonstration' by the Salvation Army with a procession, headed by a band, from the old headquarters in Windy Wynd to the Castlegate. The architect was London-born James Augustus Souttar (1840–1922), who made his home in Aberdeen from 1866.

The Citadel occupies part of the site of Aberdeen's medieval castle which stood on Castlehill and has been replaced by the Marischal Court high flats. The Castlegate was named after the castle gates, which were removed, along with the castle, after it was taken from the English by Robert the Bruce in 1308. The Old Record Office, which dated from 1789, and was a repository of public records from the town and county of Aberdeen, was demolished to make way for the Citadel.

The Scots Baronial style was inspired by the fortified tower houses of the Scottish Renaissance, reflected a revived interest in the exploration of national identity and was seen as an expression of Scottish architectural tradition. It is typified by the incorporation of architectural features such as towers, turrets, battlements, lancet windows, bartizans, balconies and crow steps. It was widely adopted in the nineteenth century to give gravitas

The Citadel and the Market.

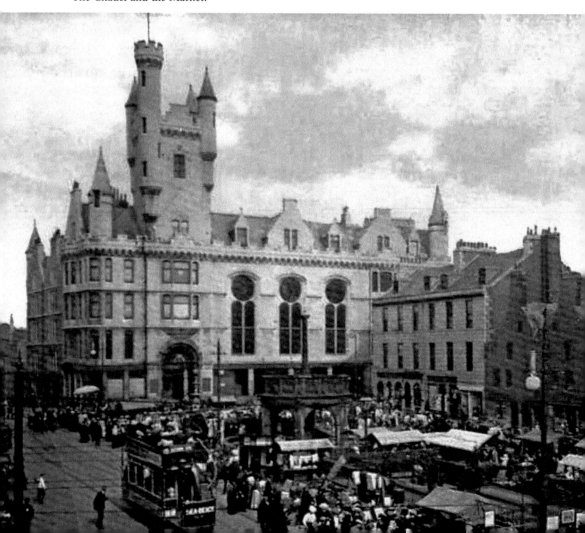

to public buildings. It is said that the Salvation Army's General Booth was impressed by the tower at Balmoral and planned a similar one for the Citadel.

The older image shows the Friday Market at the Castlegate and a tram. The trams first took to the tracks in the city in 1898. They were originally drawn by horses, before being electrified in 1902. The city's last tram operated on 3 May 1958.

4. Former North of Scotland/Clydesdale Bank, Castle Street/King Street

Archibald Simpson's classical design for the prominent site at the corner of Castle Street and King Street, which was formerly occupied by the New Inn, was the winning entry in an architectural competition for the new head office of the North of Scotland Bank. The foundation stone was laid on 20 January 1840 and it opened for business on 31 October 1842. It resulted in a landmark building, its majestic giant Corinthian-columned curved porch forming an imposing gateway to the east end of Union Street. The corner of the building is surmounted by a terracotta statue of Ceres, the Goddess of Plenty, with a lion and cornucopia, which is said to represent the Aberdeenshire area's agricultural prosperity. The building was used by the Clydesdale Bank until 1995, and the lavishly decorated banking hall is now a pub called the Archibald Simpson.

The Former North of Scotland/Clydesdale Bank.

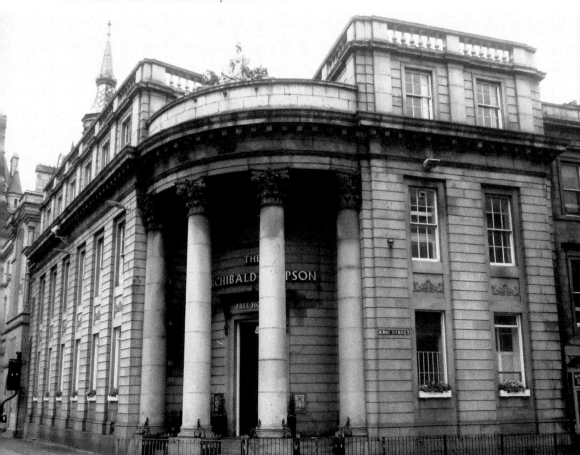

5. Town House and Tolbooth

The magnificent Town House, with its massive landmark clock tower and wealth of elaborate Scots Baronial detailing, dominates the east end of Union Street and is a noteworthy example of municipal architecture. Dating from 1874, it was designed by John Dick Peddie (1824–91) and Charles George Hood Kinnear (1830–94) following a limited competition. It represents a marked break from the classical consistency of the earlier nineteenth-century architecture in Aberdeen. The splendour of the exterior is matched by an outstanding interior decorative scheme.

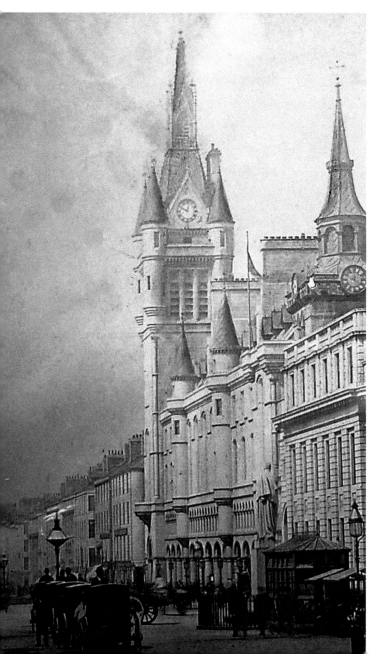

The Town House and Tolbooth.

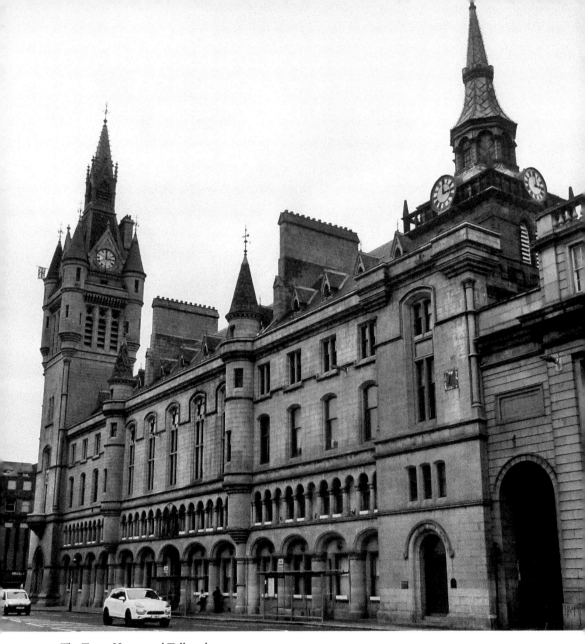

The Town House and Tolbooth.

In the year 1394, King Robert III granted to the burgesses and community a charter, dated 20th of October, by which he permitted them to build a tolbooth and court-house, 80 feet in length, and 30 feet in breadth, in any part of the town, except in the middle of the market place. This edifice was accordingly soon afterward erected, on the north side of the Castlegate, on the site of the present townhouse. On the east end of it stood the old prison, on the top of which was a small spire. In the year 1615, this part of the fabric was demolished, and a new jail erected in its place, consisting of that part of the present old work, which fronts the street. It consisted of four vaults over each other, with a platform roof, and battlement; and the expense being 5000 merks, was defrayed from the public

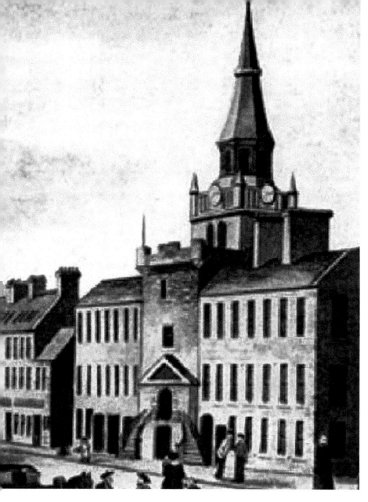

The Tolbooth.

funds of the town. In the year 1627, a square tower was erected over this building, the top of which is nearly 120 feet from the level of the ground underneath. The place of the old clock was supplied with one made by Andrew Dunlop of London, in the year 1726. The clock cost £100. The sum was paid out of the guild-wine-fund. It remained in the steeple till the year 1817, when it gave place to a new one of superior workmanship, made by Mr. John Gartly, of Aberdeen.

An Historical Account and Delineation of Aberdeen, Robert Wilson, 1822

The design of the new Town House incorporated Aberdeen's historic Tolbooth. King Robert the Bruce granted Aberdeen the right to build a Town House, which was completed in 1394. The Tolbooth was the administrative hub of Aberdeen, serving as the centre of local administration and justice, with a courthouse, jail and council chambers.

In 1616, Thomas Watson, a master mason from Auldrayne, was awarded the contract for the replacement of the old Tolbooth. Watson's original square tower was much altered and extended over the next three centuries. A spire was added in 1627, the tower was extended to the north in 1704, and a new courthouse was added to the north in 1818–20. Only the castellated prison (wardhouse) tower, with its elaborate 35-metre-high lead spire,

now survives. When the new Town House was built, the front of the Tolbooth was partly enclosed in a granite façade.

The Tolbooth opened as a local history museum in 1995 and, with its stone floors and rare original old cells, the emphasis is appropriately on crime and punishment. In 1975, an extension to the north was added to the Town House in a sympathetic design to accommodate the City Chambers. The site of the last town gibbet (gallows), where public hangings were carried out, is marked by a square of cobbles in the road at the front of the Tolbooth – the last view of the condemned person was of Marischal Street, hence the local idiom 'Ye'll end up lookin' doon Marischal Street!' as a caution to anyone on the wrong side of the law.

6. The Former Medico-Chirurgical Society, King Street

This society was instituted in 1789. It consists of two classes of members—honorary and ordinary. Ordinary members consist of medical students only. Each ordinary member, on his admission pays half a guinea to the funds of the institution. They deliver discourses on medical subjects, which are freely discussed at the subsequent meeting. The honorary members are admitted by ballot, contribute two guineas annually to the funds, and deliver discourses on the several branches of medicine. A library, consisting chiefly of medical

The Medico-Chirurgical Society.

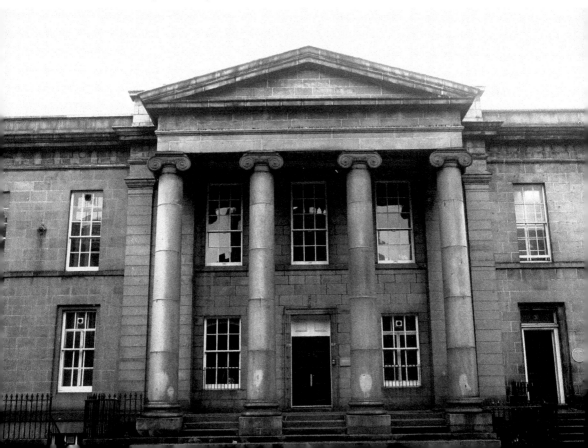

books, was instituted in February 1791, and a museum in June, the same year. An elegant house has been erected in King Street, for the expense of which, nearly £3000 have been subscribed. The whole property belonging to this society is vested in the professors of Marischal-College, as trustees.

An Historical Account and Delineation of Aberdeen, Robert Wilson, 1822

The society was founded on 14 December 1789 as the Aberdeen Medical Society (the name was changed to the Aberdeen Medico-Chirurgical Society – the Med Chi – in 1811) by a group of medical students to promote the teaching of medicine in Aberdeen, although it seems that the intention may have been more nefarious as one of the original founders was caught grave robbing in 1801. Before the Anatomy Act of 1832, which expanded the legal supply of medical cadavers, there were insufficient bodies available for anatomical dissection in the medical schools. Executed criminals were the main source, but this had been reduced due to a decrease in executions in the early nineteenth century. The medical schools came to rely on bodies that had been acquired by disreputable means and grave robbing by resurrectionists became one of the main sources. This gave rise to particular public fear and watchtowers were set up in graveyards so that relatives could watch over the graves of their dearly departed for such time that the bodies would no longer be of use for dissection.

The Medico-Chirurgical Hall, with its giant Ionic portico, is a commendable example of Greek Revival architecture. It was designed as a meeting place and library for the society by Archibald Simpson and was completed in 1820. It was the first building on the west side of King Street and the first major granite building by Simpson. In order to give the building prominence, it was a condition of the feus of the adjoining properties that they should be set back from the frontage of the Med Chi building. The society moved to Foresterhill in 1973 and the building is now used as offices.

The adjoining buildings, despite being built by different architects and at different times, form an architecturally articulate design with the Med Chi building. The building to the immediate south dates from 1823 was designed as the County Record Offices by John Smith. The property to the north was designed as a town house for John Webster, the Lord Provost of Aberdeen, and dates from 1840. The group makes an important contribution to the planned layout of King Street.

7. St Andrew's Cathedral, King Street

Mr Joseph Kennedy, US Ambassador and a deputation of Bishops of the American Episcopal Church are to attend on September 6 the inauguration of St Andrews Episcopal Cathedral, Aberdeen, of a memorial to Bishop Samuel Seabury, the first American Episcopal Bishop, who was consecrated in Aberdeen. The funds for the memorial, which will consist of extensions to St Andrew's Cathedral, have been raised by American Episcopalians. After the close of the American Revolution the Episcopal clergy in Conneticut met in 1793, and elected Dr Samuel Seabury, an American citizen, to their Bishop.

Scotsman, 2 May 1938

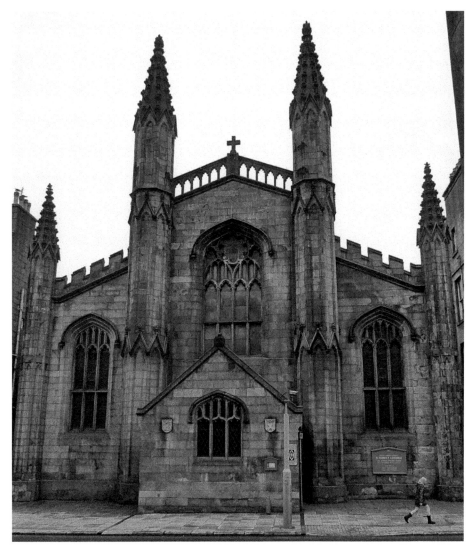

St Andrew's Cathedral.

King Street was begun in 1804, initially with a unified classical façade. However, the Episcopalian community bought a central feu on the street to build a Gothic church. The original Perpendicular Gothic building was designed as St Andrew's Chapel by Archibald Simpson and opened in 1817; it was raised to a cathedral in 1914. The frontage is in sandstone, rather than granite, for reasons of economy, which Simpson strongly opposed. The front porch was added by Sir Robert Lorimer in 1911.

Samuel Seabury (1729–96), the first American Episcopal bishop, was consecrated in Skinner's house, Longacre, Aberdeen, on 14 November 1784 – the event is commemorated by a plaque at Marischal College – and the church has close links with the American Episcopal Church. In the 1930s, the American Episcopal Church funded the renovation and extension of the church, the inauguration of which, in 1938, was attended by Joseph

Kennedy, President John F. Kennedy's father, as US Ambassador to the UK. A plan to build a new larger cathedral with money raised in America fell through due to lack of funding following the Wall Street Crash. The work on the church in the 1930s was designed by Aberdeen-born Sir John Ninian Comper (1864–1960), a renowned church architect. Comper significantly remodelled the building and his embellishment of the interior of the church remains largely intact. The vaulted ceiling includes ornamental panels depicting the American states and local Jacobite families.

8. Aberdeen Arts Centre, Former North Parish Church, King Street

The North Parish Church was completed in 1830 in the fashionable Greek Revival style to a design by John Smith, Aberdeen's city architect. It is a significant landmark on a corner site on the north side of King Street at the junction with Queen Street.

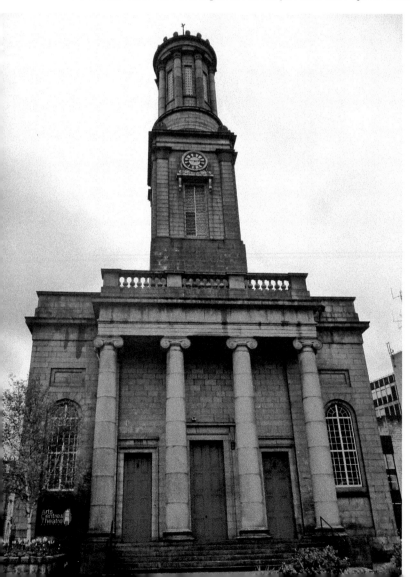

Aberdeen Arts Centre.

With its imposing four-column Ionic portico and distinctive square plan clock tower, it is considered to be a tour de force of Greek Revival architecture and one of Aberdeen's finest classical churches. The circular top stage is based on the Choragic Monument of Lysicrates near the Acropolis of Athens, which dates from 334 BC and represents the first known use of the Corinthian order on the exterior of a building. The monument was a much favoured motif of the nineteenth-century Greek Revival and was reproduced widely in buildings of the time. It was due to the shape of this feature that it was known as the Pepperpot Kirk.

In the early 1960s, the church was converted for use as an art centre with a theatre space and an exhibition area.

9. Marischal College

Marischal College is Aberdeen's largest granite building, the second largest in the world, only surpassed by the El Escorial Palace, the historic residence of the King of Spain, and a striking icon of the Granite City.

Marischal College was founded as the Marischal College and University of Aberdeen in 1593 by George Keith, Earl Marischal of Scotland – the University of Aberdeen was formed following the union of Marischal College and King's College in 1860. The college was built on the site of a disused Franciscan friary, which was replaced by a William Adam-designed building in the mid-eighteenth century. These older structures were demolished in 1835 for the construction of the new college buildings.

Archibald Simpson's Tudor-esque U-plan central quadrangle in white Rubislaw granite was completed in 1844. From 1891, Alexander Marshall Mackenzie (1848–1933) extended the existing Gothic-style tower to form the 85-metre-high (279-foot) Mitchell Tower and added the Mitchell Hall to the rear of the quadrangle.

In 1906, Mackenzie designed the outstanding multi-pinnacled and crocketed granite façade to Broad Street, which has been described as being in the 'skyscraper-perpendicular Gothic style'. The finishes to the granite were revolutionary due to technological

Marischal College by Archibald Simpson.

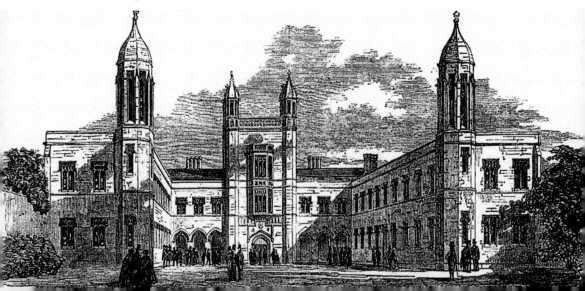

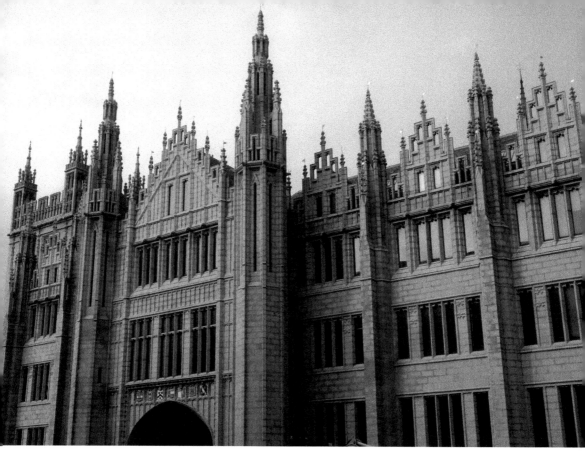

Above and below: Marischal College.

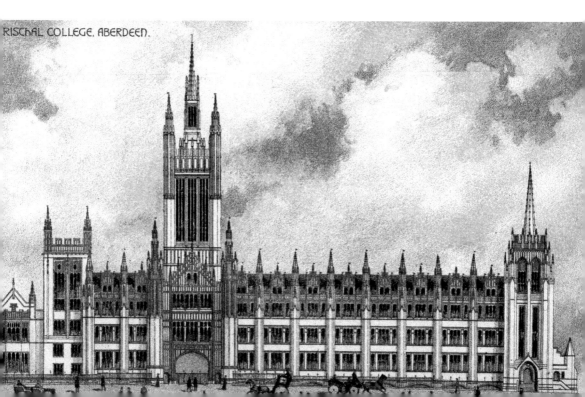

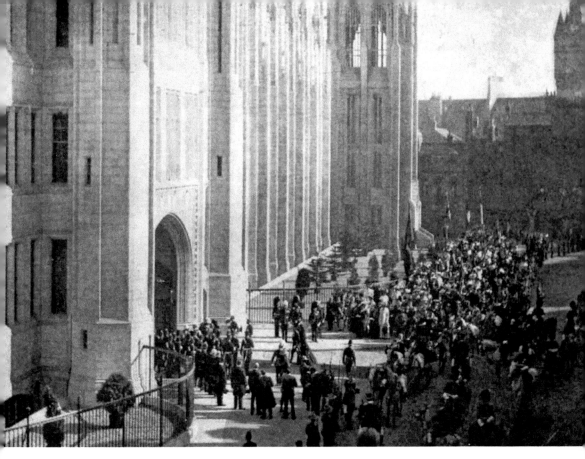

Opening of New Buildings at Marischal College.

improvements in the methods of cutting granite. The building was formally opened by King Edward VII in September 1906.

In the early part of the twenty-first century, many university functions had moved to other locations in the city and Marischal College was underused. In 2006, most of the Marischal College buildings were leased to Aberdeen City Council. After a major refurbishment, the building opened as the new council headquarters on 21 June 2011. The university retained parts of the building including the Mitchell Hall and Marischal Museum.

10. Provost Skene's House, Flourmill Lane

Provost Skene's House dates from 1545 and is one of the oldest buildings in Aberdeen. The fortified house takes its name from Sir George Skene of Rubislaw, a wealthy merchant and Provost of Aberdeen from 1676 to 1685, who owned the house in the seventeenth century. It was also known as Cumberland's House from its use by the Duke of Cumberland in 1746 on route to Culloden.

In 1622, Matthew Lumsden bought and enlarged the original house – Lumsden's coat of arms, dated 1626, is inscribed on one of the dormer gables. In 1669, George Skene took ownership of the house and reconstructed the original building. The house was subdivided into two tenements in the 1730s, but was amalgamated again in the mid-nineteenth century.

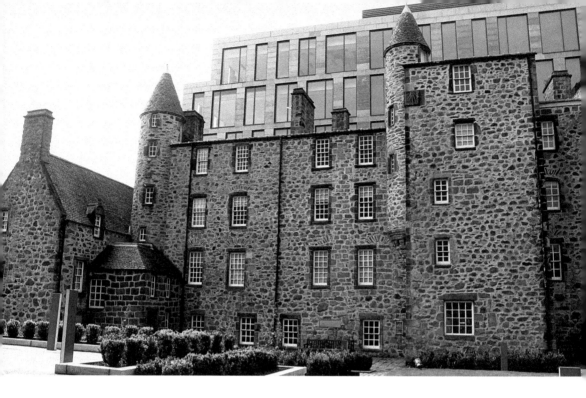

Above and below: Provost Skene's House.

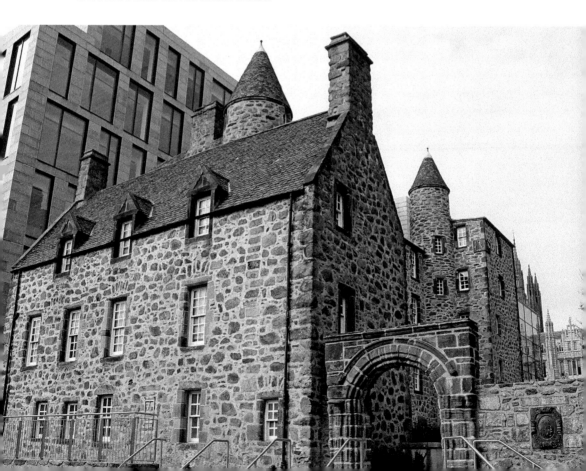

By this time, conditions in the immediate area had declined significantly. In 1879, the house was leased to the Aberdeen Lodging House Association and it was known as the Victoria Lodging House. The house fell into a state of disrepair and many of the buildings surrounding it were demolished in the 1930s. It was saved and restored following a public campaign. The interior is of exceptional quality with seventeenth-century plasterwork and painted decoration.

11. Provost Ross's House and Aberdeen Maritime Museum, Shiprow

Provost Ross's House, which dates from 1593, was built by architect George Johnsone and master mason Andrew Jamesone for Robert Watson, a successful merchant. It occupies a prominent position overlooking the harbour and was a house of some prestige, at a time when the Shiprow was the principal street in the commercial heart of Aberdeen. The house takes its name from John Ross of Arnage, who was a shipowner and Provost of Aberdeen from 1710 to 1712, and acquired the house in 1702.

Over the years, the area around the house became dilapidated and overcrowded, and was the subject of slum clearance in the 1890s. The house fell into a long steady decline and was divided up into tenement flats. By 1950, it had reached near slum conditions and was proposed for demolition, along with many other buildings in the area. The National Trust for Scotland stepped in to acquire the property and restored the building in 1954, under the guidance of Alexander George Robertson Mackenzie. It now forms part of the Aberdeen Maritime Museum complex.

The Aberdeen Maritime Museum celebrates Aberdeen's long and illustrious links with the sea. The exceptional collection includes exhibits relating to fishing, shipbuilding, whaling,

Provost Ross's House and Aberdeen Maritime Museum.

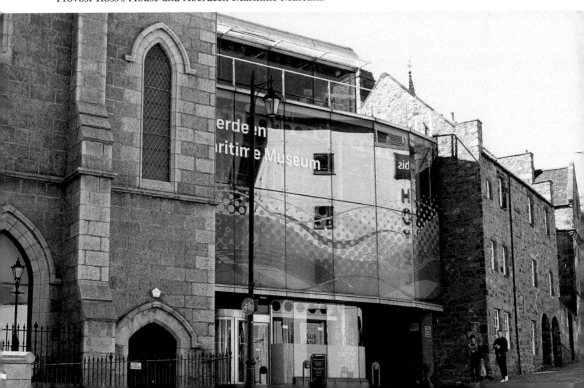

port history and offshore oil production. It was first established in Provost Ross's House in 1984. Trinity Congregational Church was acquired shortly after with the intention of extending the museum. In 1996, a boldly designed curved glass and steel curtain wall was built to link the two historic buildings. The extended museum opened in May 1997. The building and collection have since won a number of prestigious awards.

12. Harbour Office, Regent Quay

In ancient times, the only piece of artificial work in the harbour, was that part of the old quay known by the name of the quay-head, opposite to the weigh-house. At that time, the harbour was nothing else than a basin, which spread from the sloping ground on the south side of Castle-Street to the island in the middle of the river, called the Inches. But the magistrates, in the year 1623, extended the quay from the weigh-house to Footdee. About the year 1755, the magistrates built the Pocra-pier, long known by the name of the new pier, situated near the building anciently used as the block-house. For ages, a bar was formed at the mouth of the harbour, consisting of sand and gravel, which gave the citizens perpetual trouble in removing it, that vessels might have free passage. About the year 1770, improvements relative to this constant impediment to shipping, were projected by the celebrated Mr. Smeaton. He advised that a quay should be erected on the north side of the harbour, which, while it should confine the river within narrow bounds, would tend to remove the sand-bank which had accumulated. On Monday the 5th June 1775, the foundation-stone of the north pier was laid at the Sandness with Masonic honours, in presence of the magistrates and a numerous concourse of people. The quay was built in the course of six years, at an expense of £18,000 sterling. An act was granted 18th May 1810, empowering the magistrates and council to construct wet and graving docks, and to extend the north pier farther eastward, according to Mr. Smeaton's original design. The improvements proposed to be executed under a new act, were projected by Mr. Telford, and approved by Mr. Jessop, two eminent engineers. The north pier has since been extended about 900 feet, farther seaward. A breakwater from the southern shore, extending about 800 feet, for the purpose of narrowing the channel, and protecting the entrance from the south-easterly storms, has been also constructed. In the interior of the harbour a wharf-wall, called Waterloo-Quay, extending nearly 900 feet, has been built on the east side of what is called Footdee-burn. It is so constructed, as to form part of the general plan of converting the harbour into a wet dock; and gives excellent berth to the larger class of shipping.

An Historical Account and Delineation of Aberdeen, Robert Wilson, 1822

In 1136, King David granted the bishops of Aberdeen the right to charge taxes on trade passing through the port, and the harbour is said to be the oldest business enterprise in Britain. The harbour was fundamental to Aberdeen's development over the centuries and the foundation of the city's history. The harbour was expanded following the introduction of steam ships in the 1880s and the Harbour Office building dates from that period of prosperity at the end of the nineteenth century. It was designed by Alexander Marshall Mackenzie. With its tall clock tower and prominent corner site, it dominates the harbour area – the pediment is placed off-centre, as the primary view of the building was intended to be from the harbour entry.

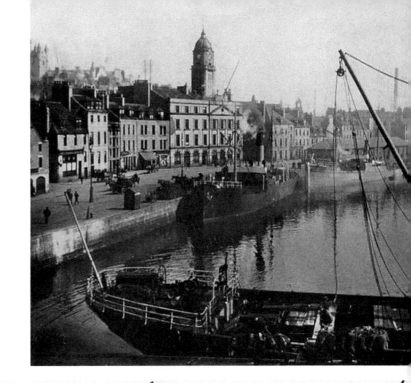

Right: The Harbour.

Below: The Harbour Office.

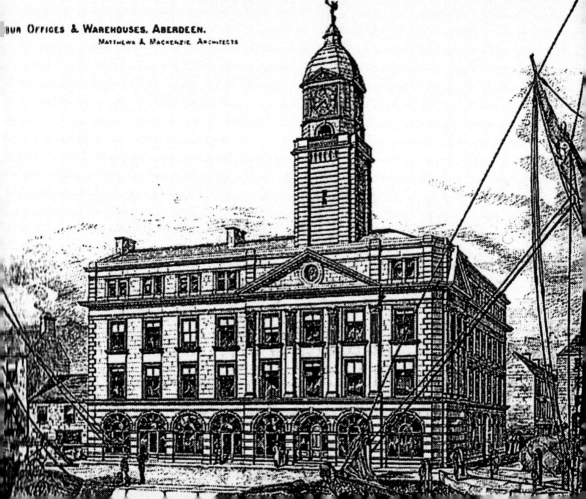

OUR OFFICES & WAREHOUSES, ABERDEEN.
MATTHEWS & MACKENZIE ARCHITECTS

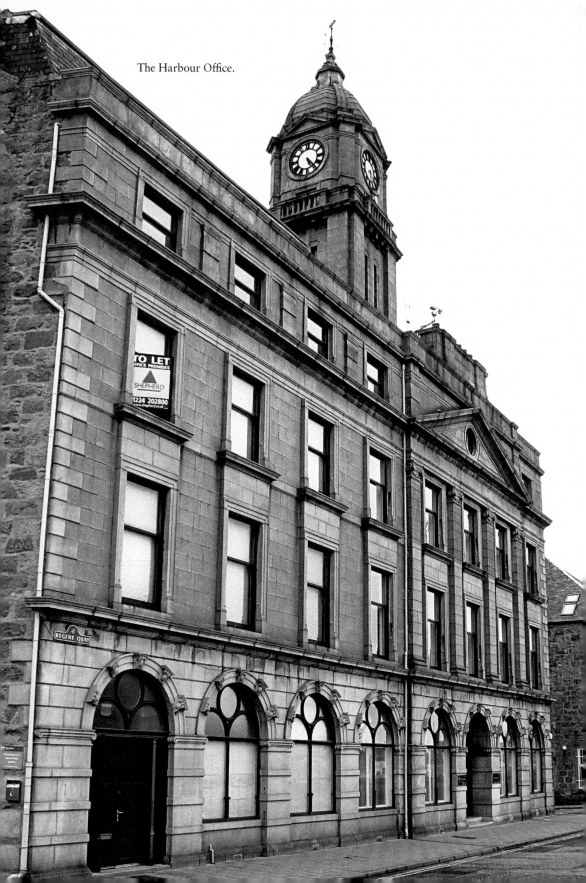

The Harbour Office.

13. Former Custom House, Regent Quay

The elegantly proportioned Georgian town house overlooking the harbour on Regent Quay dates from 1771. It was originally built as a private house for a prosperous landowner, James Gordon of Cobairdy, and became the Aberdeen Customs House in the 1890s.

The Custom House.

Customs and Excise officers had an essential role in the work of the harbour managing the import and export of goods and assessing cargoes for duty. Since 2006, the building has been converted to office accommodation.

14. The Tivoli Theatre of Varieties, Guild Street

A visit to the theatre in the early days of the stage in Aberdeen seems to have been a fairly boisterous affair. The Theatre Royal opened in 1795 in a converted house on Marischal Street. It was described as 'rickety' and was mainly frequented by 'unruly sailors'. The audience would demand the raising of the curtain with shouts of 'Up wi' the hippin!' (hippin was a colloquial name for a baby's nappy). However, it did not fare as badly as the Bon-Accord Music Hall on St Nicholas Lane, which, after a short and chequered career, was wrecked by a dissatisfied audience.

Her Majesty's Opera House on Guild Street, which opened on 19 December 1872, was a much more sophisticated venue. The Venetian Gothic polychromatic frontage in red and grey granite is a striking landmark feature on Guild Street. The architects were local man James Matthews, a later provost of Aberdeen, and the London-based Charles John (CJ) Phipps (1835–97), one of the best theatre specialists of the time.

On the opening night, the audience of 1,400, who had paid double the normal price of admission, were noted as 'giving vent to their admiration of the rich decoration of the theatre in hearty and prolonged cheers when the lights were put up'. The first night play was *The Lady of Lyons*. At the end of the show Mr Phipps, the architect, and Mr Brown, the superintendent of works, were called on by the audience to take a bow.

The auditorium was altered in 1897 by Frank Matcham and closed temporarily in 1906 when the larger His Majesty's Theatre opened. The interior of Her Majesty's was extensively reconstructed and redecorated in 1909 by Frank Matcham and reopened on 18 July 1910 as the Tivoli Theatre of Varieties. Matcham (1854–1920) was one of the most esteemed theatre architects of the time. His Edwardian baroque decorative scheme for the auditorium, which survives relatively unaltered, is considered to be one the best remaining examples of his work in the United Kingdom.

The Tivoli Theatre of Varieties, a notable addition to the places of entertainment in Aberdeen was opened yesterday afternoon. The Tivoli - formerly Her Majesty's Theatre - has been entirely reconstructed and the building will accommodate 1600 to 1700 persons. The scheme of decoration is exceedingly effective, and the theatre presented a magnificent spectacle to a crowded house at the opening matinee. Many things are in its favour. It is situated in a part of the town which has long been recognised as the centre of attraction for amusement lovers; it is a bright, cheery little theatre and contains all the adjuncts necessary to a well-appointed place of recreation. An excellent company has been got together, and also with the view of pleasing holiday audiences the programme is of a kind to attract all sorts and conditions.

Press and Journal, 19 July 1910

The Tivoli was a hugely popular variety theatre and hosted many famous performers over the years. The summer shows were particularly popular and regularly played to packed houses.

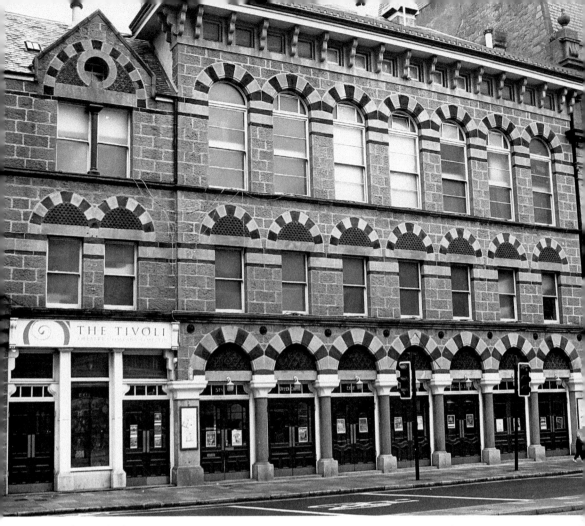

The Tivoli Theatre.

The theatre became a bingo hall in 1966, which closed in 1998. After a period of disuse and much debate about its future, the Tivoli was restored and opened again as a theatre on 25 October 2013. It remains an exceptional and unique, near complete example of a Victorian theatre by Phipps and Matcham, two of the theatre world's most renowned architects.

15. Aberdeen Railway Station, Guild Street and Union Square

Aberdeen railway station dates from 1916. It replaced an earlier station which dated from 1867 and had become inadequate to cope with the increased traffic. It was known as the Joint Station, as it was owned by two railway companies – the Caledonian Railway and the Great North of Scotland Railway. The building was designed by JA Parker, the chief engineer of the Great North of Scotland Railway, in sandstone with a Beaux Art frontage and large open glazed concourse. It was the last major station to be built in Scotland. The frontage of the station now forms part of the covered plaza of the Union Square retail development, which opened in 2009.

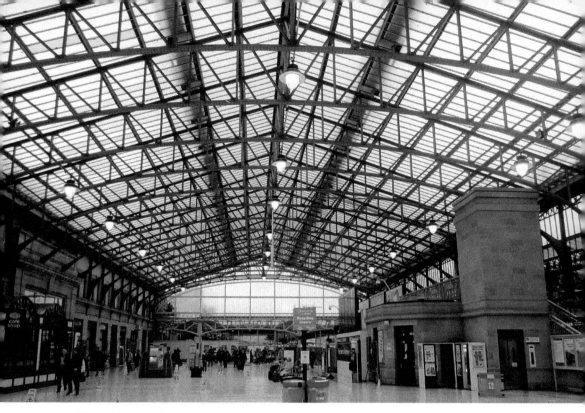

Above: Aberdeen Station concourse.

Below: Aberdeen Station frontage.

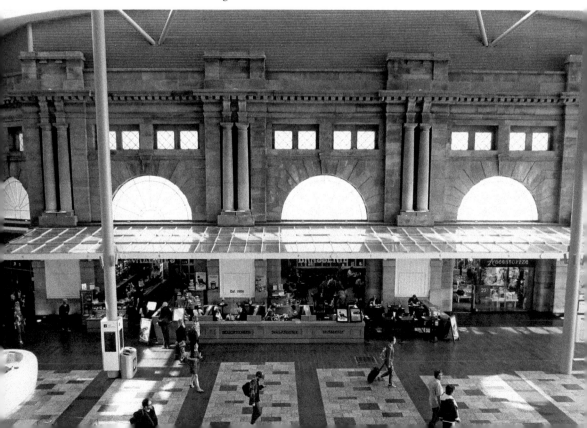

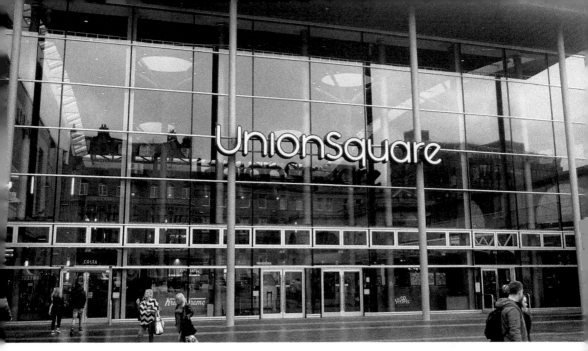

Union Square frontage.

16. Former Aberdeen General Post Office, Crown Street

Aberdeen's new post office was opened with full ceremonial on Saturday (6 April 1907) by Mr Sydney Buxton, the Postmaster General. The event was one of much interest to the general public, who assembled in great numbers in Union Street, Crown Street and Dee Street, and at every point of vantage from which a view of the opening ceremony could be obtained. In the clear atmosphere, with the sun shining brightly upon it, the new Post Office, with its towers, battlements and bartisans looked its best, the white Kemnay granite and the darker Rubislaw stone of which it is built sparkling in the sun's rays, while the clean cut carvings, with which the fronts are richly embellished, were seen to the fullest advantage, and were greatly admired by the public. Crown Street was lined on both sides by naval and militray detachments and in the brilliant sunshine, the display was exceeingly picturesque. The pavements on both sides of Crown Street were lined with people tightly packed. The new builidng was formally handed over by Mr WT Oldrieve, principal architect for Scotland, HM Office of Works; and Mr Buxton - having been presented with a gold key by Mr HP Bisset, the principal contractor - unlocked the gate at the main public entrance, and declared the builidng open.

Press and Journal, 8 April 1907

The completion of the new Post Office has added another to the many fine buildings, which have in recent years helped to beautify Aberdeen. Architecturally, the Post Office takes a high place. The main front on Crown Street is very well balanced, and is considered by experts to be one one of the finest pieces of workmanship of which the city can boast. With its towers, bartisans, and battlemented parapets it is imposing and pictureque, and externally and internally it is a Post Office of which the citizens may well be proud.

Press and Journal, 6 April 1807

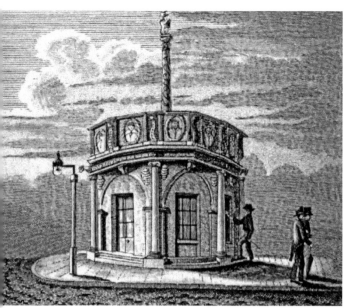

Left: The post office in the Mercat Cross.

Below: Crown Street and the post office.

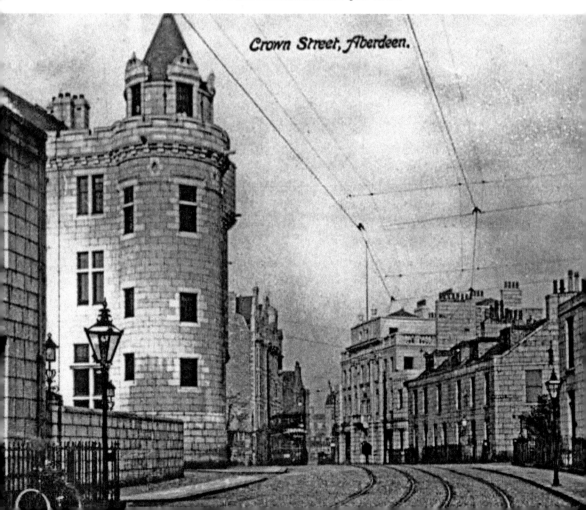

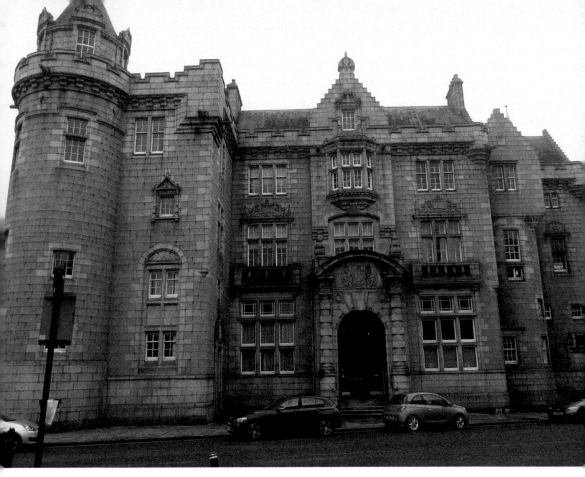

The former post office.

Crown Street was developed in the 1820s as a residential area. Later in the nineteenth century, a number of the residential properties were demolished and replaced by commercial buildings.

The Aberdeen Post Office has occupied a number of different premises over the years. In April 1822, it was moved from the Netherkirkgate to the Mercat Cross – four 'hucksters' booths had previously occupied the Cross, but had been removed in 1821 when repairs were carried out. However, with a population estimated at 45,000 at the time, the size of the Mercat Cross Post Office soon proved too small and in 1823 it moved to premises at 40 Union Street. Two years later it transferrd to the Netherkirkgate and then to Adelphi Court, in 1840. The introduction of the popular Penny Post on 10 January 1840 and the invention of adhesive stamps by James Chalmers of Dundee in 1841 significantly increased the accessibilty of the postal service – people were even encouraged to have slits added to their doors for the delivery of letters. In June 1842, the Post Office moved to a new building at 5 Market Street, opposite the New Market, and by 1850, 27,000 leters were being delived weekly in Aberdeen. This resulted in an increased demand for an improved post office service.

Aberdeen's new General Post Office was opened in 1907. The grand Baronial building was designed by William Thomas Oldrieve (1853–1922), the Principal Architect for Scotland in HM Office of Works. The grandeur of the granite building reflected the mercantile and civic

importance of the postal service at the time. The building included a large public office, telegraph school, telephone room, sorting office and telegraph delivery room with storage for the telegraph delivery staff's bicycles. The building was converted into flats in 1999.

17. St Nicholas Church, Union Street

St Nicholas Church, Aberdeen's 'Mither Kirk', dates from the twelfth century and by the fifteenth century it was one of the largest and most important burgh churches in Scotland. In 1560, at the time of the Reformation, it was divided into the West Church and East Church. East St Nicholas was restored by Archibald Simpson in 1835–37, but burnt down in 1874 when a faulty water-cooled gaslight caused a fire. It was restored in the 1870s by John Smith. On 11 May 1887, a new peel of bells, cast in Belgium, was paraded through the city with great pomp and ceremony in a procession that lasted two and a half hours. West St Nicholas was rebuilt from a ruin in around 1750 to plans prepared by James Gibbs.

THE EAST AND WEST CHURCHES.

St Nicholas Church.

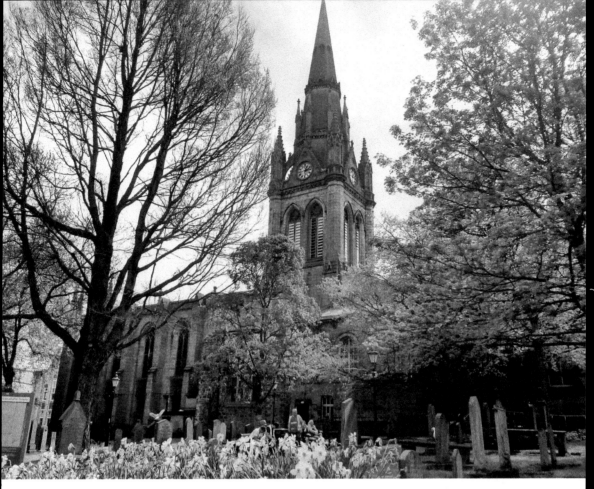

Above: St Nicholas
Church.

Right: Houdini
on the left visiting
the grave of John
Henry Anderson.

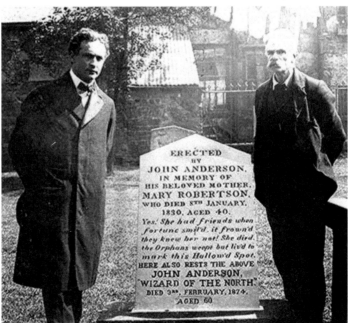

ERECTED
BY
JOHN ANDERSON,
IN MEMORY OF
HIS BELOVED MOTHER,
MARY ROBERTSON,
WHO DIED 8TH JANUARY,
1830, AGED 40.
Yes! She had friends when
fortune smil'd, it frown'd
they knew her not! She died,
the Orphans weept but liv'd to
mark this Hallow'd Spot.
HERE ALSO RESTS THE ABOVE
JOHN ANDERSON,
"WIZARD OF THE NORTH,"
DIED 3RD FEBRUARY, 1874,
AGED 60

The churchyard has memorials to a number of celebrated Aberdonians: painter William Dyce; architect Archibald Simpson and John Henry Anderson, the 'Great Wizard of the North'.

John Henry Anderson (1814–74) was probably the finest magician that Scotland ever produced. Anderson was born in 1814, the son of a tenant farmer, at Craigmyle, near Aberdeen. He was orphaned at an early age and started work as an apprentice to the local blacksmith. However, he had ambitions to be an actor and joined up with a group of touring players. During this period Anderson saw his first magic act and was fascinated by the performance. He made and acquired apparatus to put together a show and started to develop his own special brand of magic.

Anderson made his debut as a magician at Scottie's Show in John Street, Aberdeen, and shortly afterwards, in March 1837, he had received £10 for a performance at Brechin Castle for Lord Panmure, and an endorsement which he quoted on his advertising material: 'I have no hesitation in saying that you far excel any other necromancer that I have ever seen, either at home or abroad.' This marked the start of his extravagant advertising and he

The Screen Wall, St Nicholas Church.

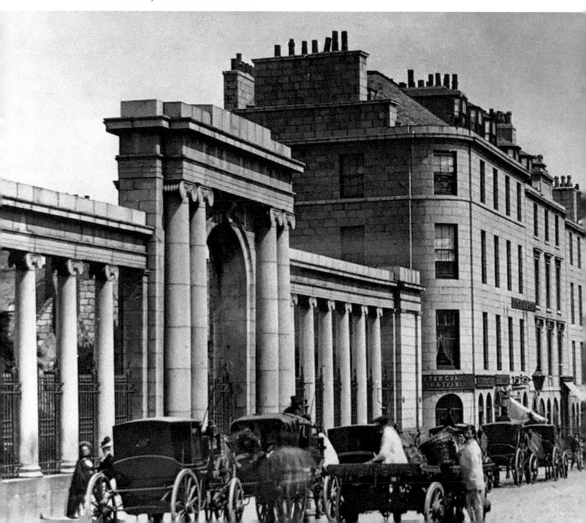

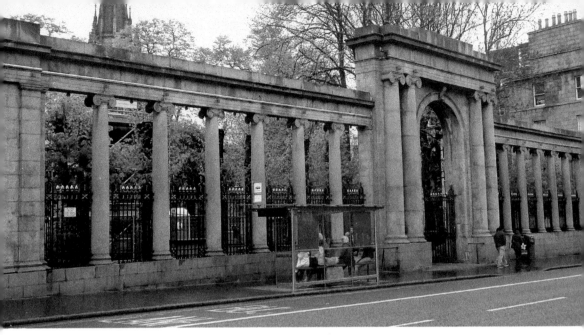

The Screen Wall, St Nicholas Church.

was to become 'the greatest exponent of publicity and promotion in the history of magic'. This included the issue of butter pats inscribed 'Anderson is here' to hotels in towns where he appeared.

At this time Anderson was billing himself as 'The Great Caledonian Conjuror' and it was not until around 1840 that he emerged as the 'Great Wizard of the North', a title he claimed had been bequeathed to him by Sir Walter Scott, the original Wizard of the North.

Anderson, who was a showman in the grand manner, is credited with moving magic from fairgrounds to the theatre and was believed to be the first conjuror to ever pull a rabbit from a hat. His many illusions included the *Inexhaustible Bottle*, which produced any drink requested by members of the audience, and the *Great Gun Trick*, in which Anderson was seemingly able to catch a bullet fired at him from a musket. The *Gun Trick* was described as 'the most wonderful feat ever attempted by man' and was always kept as the finale of his act, in order that 'ladies might withdraw, to avoid witnessing the illusion'.

His tours were remarkable for the time. He travelled with his show to the United States, Canada, most European countries and was one of the first show business acts to perform in Russia. One of the highlights of the Great Wizard's career came in 1849, when he was summoned to Balmoral to give a command performance for Queen Victoria.

In 1845, Anderson poured the profits from his tours into the erection of the Glasgow City Theatre on Glasgow Green. The City Theatre was 'the biggest and most magnificent that Glasgow had ever seen' and was 'unequalled in the country for its interior splendour'. However, on 18 November 1845, the theatre was burned to the ground. Anderson was underinsured and was left badly in debt. He started touring again in an attempt to retrieve his fortunes. In 1856, another fire, at the Covent Garden Theatre in London, which he had leased, plunged Anderson even more deeply into debt. He continued to tour with his magic show until his death in Darlington on 3 February 1874. The Great Wizard was brought back to Scotland and was buried in St Nicholas churchyard.

In July 1909, Harry Houdini (1874–1926), the renowned escapologist, visited Aberdeen for a run of shows at the Palace Theatre. His pre-show escape involved jumping into the harbour tied up in chains. Houdini also took time to visit the grave of John Henry Anderson, whom he cited as an inspiration.

The twelve granite Ionic columns that form the screen wall at the front of the churchyard date from 1829 and are a distinctive feature on Union Street. The colonnade was designed by John Smith to commemorate John Forbes of Newe, a local philanthropist who bequeathed funds for the building of the Royal Cornhill Asylum.

18. Union Bridge

In the year 1796, a plan delivered by Mr. Charles Abercrombie, a surveyor of eminence, for opening a street from the west end of Castle-Street, through St Catharine's hill, and over the Denburn, by means of a bridge, was laid before a general meeting of the trustees of the turnpike-roads of the county. An act was passed on the 4th April 1800, empowering the trustees to open two streets and to purchase from the proprietors the houses and lands in the line of the direction of these streets or avenues. Contrasting Aberdeen now with what it presented to the eye of the stranger 25 years ago, an estimate may be formed of the advantages resulting from the labours of the trustees. At that period, the access to the city was by dirty, narrow, and dangerous passages. Now the very spacious and elegant entrances, both from the north and south, call forth the admiration of every stranger; while the health, the comfort, and the convenience, of the inhabitants have been greatly

Union Bridge.

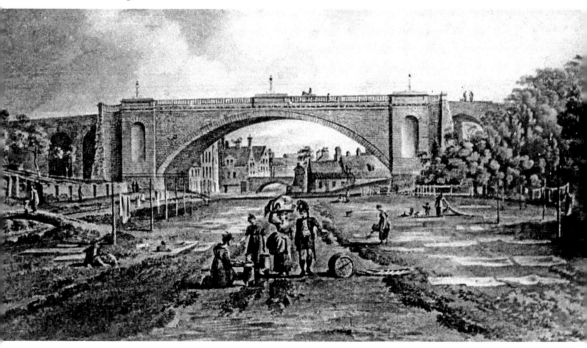

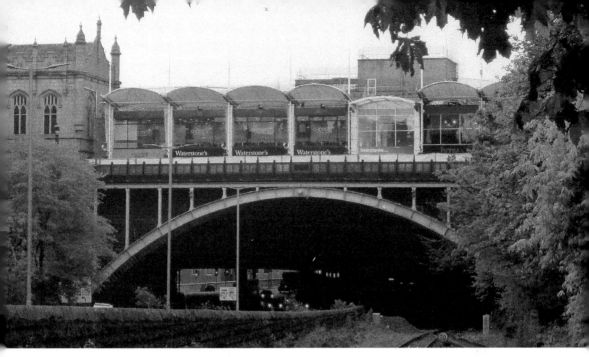

Union Bridge.

promoted. The streets that have been formed under their direction are as follow viz. Union-Street, leading to the bridge of Dee, which passes over Putachieside, and Correction-wynd on stone arches, and over the Denburn on the elegant bridge called Union-bridge, being 70 feet broad: and King Street, 60 feet broad, which was opened from the north of Castle Street, in order to form a communication with the Peterhead and Ellon road. Another street, named St. Nicholas-Street, was afterward opened from the north of Union-Street, leading through Tannery- Street, and crossing the Nether and Upperkirkgates, thus affording a direct passage to the Banff and Huntly Roads. In short, the improvements that have been effected, have proved advantageous to the public, to private individuals, and to societies, and promoted the comfort of the inhabitants, and elegance of the city; but at an expense which has unfortunately proved injurious to the treasury of the town.

An Historical Account and Delineation of Aberdeen, Robert Wilson, 1822

The only bridge worthy of notice in the city, is that which was built in the line of Union Street, across the Denburn valley, under an Act of Parliament which was obtained in 1800. Union Bridge, as it is called, consists of one open arch of 132 feet span, considerably less than a semi-circle, with three blind arches, one on the west and two on the east. The top of the parapets is 52 feet above the level of the ground below. The whole structure is composed of native granite.

A New History of Aberdeenshire, Alexander Smith, 1875

Union Street crosses over a deep ravine which happens to intersect it, and through which runs a stream called the Den Burn, by a bridge of one arch; the span of which, 132 feet, with a rise of only 22, is believed to have no equal in the world.

The Picture of Scotland, Robert Chambers, 1828

The Union Bridge carries Union Street soaring high over the Denburn Valley and Union Terrace Gardens. The bridge was a major engineering achievement and a critical element in the audacious and inventive improvements to Aberdeen in the early nineteenth century, which included the removal of the top of St Katherine's Hill. It consists of a single 130-foot (40-metre) arched span of granite. The bridge was built between 1802 and 1805 to a design by Thomas Fletcher, with advice from Thomas Telford. An earlier scheme of 1801 by David Hamilton was abandoned due to potential faults in the design. The bridge roadway was widened in 1905–08 when the balustrade and the leopard statuettes (Kelly's Cats), attributed to William Kelly, were added. The south side of the bridge was redeveloped with a new shopping centre in 1964.

19. Former Northern Assurance Building: The Monkey House, Union Street

The striking Italian Renaissance former Northern Assurance Building occupies a prime location at the corner of Union Street and Union Terrace. It dates from 1885 and was designed by Alexander Marshall Mackenzie.

The Northern Assurance Company was established in Aberdeen in 1836 as the North of Scotland Fire and Life Assurance Company. It was renamed the Northern Assurance Company in June 1848. The company was acquired by Commercial Union in 1968.

The frontage of the building is richly decorated with Ionic columns, surmounted by carved garlands, between the first-floor windows. The corner entrance is screened by four Doric columns.

The former banking hall was a public house known as the Monkey House for a number of years until 2016 and the building has been known locally as the Monkey House for

The Monkey House.

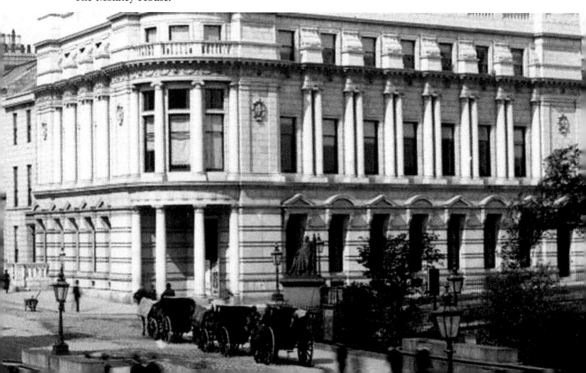

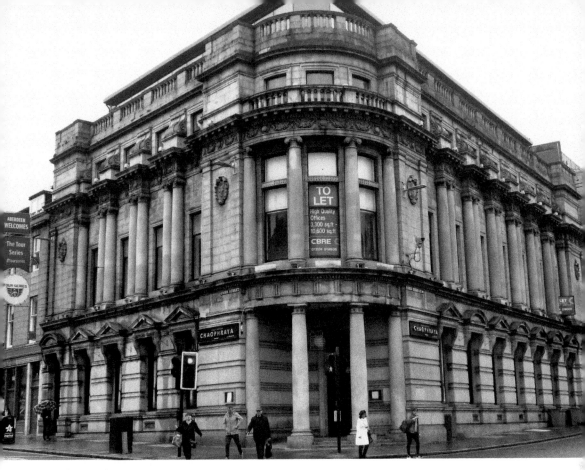

The Monkey House.

many years. There seems to be some doubt about the derivation of its sobriquet – the four columns perhaps give it a cage-like appearance or possibly the name derived from the many office workers that could formerly be seen at work through the windows.

20. The Former Trinity Hall, Union Street

The Incorporated Trades of Aberdeen is a society of craftsmen formed in the sixteenth century. The craftsmen united together to increase their influence on trade issues, ensure standards of quality, and oversee apprenticeships. The seven trades were the Hammermen, Bakers, Wrights and Coopers, Tailors, Shoemakers, Weavers and Fleshers.

In 1632, the society's early meeting place was a building in Shiprow that had previously been the Trinitarian friary – the Trinity Hall. In 1846, the society moved to grand custom-built premises on a prominent site on the south-east corner of Union Bridge. The Tudor-Gothic façade with its hood moulds, arched windows, tracery, crenellated parapet and turrets is a striking composition among the more restrained classical frontages on Union Street. The interior with its hammer beam roof dining room was equally outstanding. The architects were John Smith (1781–1852) – this building earned him the title 'Tudor Johnnie' – and his son, William (1817–91).

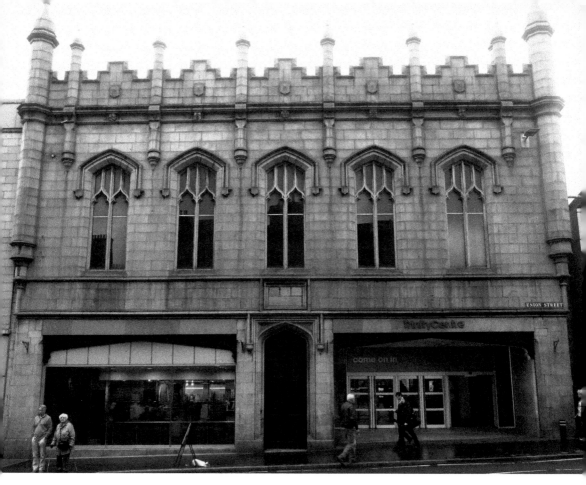

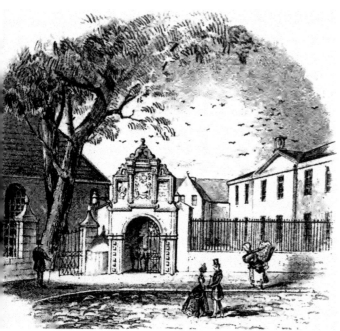

Above: The Trinity Hall.

Left: The Old Trinity Hall.

The building was substantially altered to create the Trinity Shopping Centre in the 1960s. The stained-glass windows representing the trades were moved to the new Trinity Hall on Holburn Street, which dates from 1967.

21. The Music Hall, Union Street

The Public Assembly Rooms, intended chiefly for the accommodation of the united meetings of the counties of Aberdeen, Banff, Kincardine, and Forfar, are situated in Union Street. It is decorated with a portico of six columns of the Greek Ionic order, being 30 feet in height, and projecting 10 feet from the wall. The principal entrance, under the portico, conducts into an outer vestibule leading to the grand saloon, which is divided into three compartments by fluted Ionic columns, with ornamented capitals, and corresponding pilasters. The ceiling is a dome finished with coffering. In the centre of the building, and opening into the saloon through a screen of columns, is a spacious gallery or promenade,

Union Street and the Music Hall.

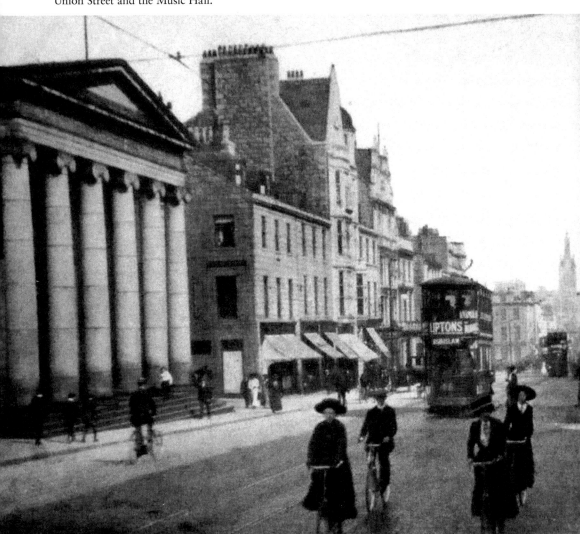

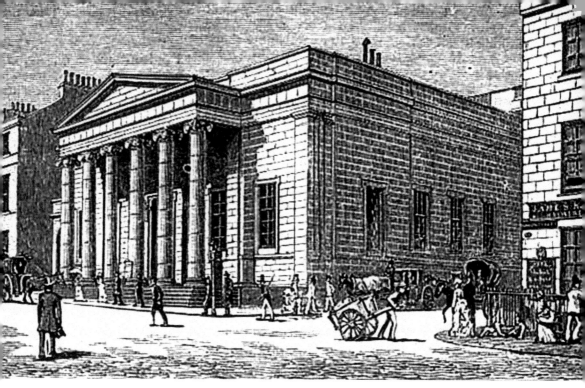

The Music Hall.

finished with pilasters, and an arched and panelled ceiling. It communicates on one side with the ball-room, and, on, the other side, with the supper or refreshment-room. Communicating with this room is the card-saloon, which is a rotunda. It is decorated with eight fluted Corinthian columns and corresponding pilasters, over which the entablature forms a circle, from which springs the ceiling in form of a flat dome with eight compartments intended to be filled with appropriate paintings. Within the columns are four spacious recesses for sofas with niches in the wall behind. The end of the gallery opens into the banqueting-room. The walls are finished with pilasters in imitation of Sienna marble, with ornamented capitals. At one end is a large semi-circular recess, with an orchestra and retiring closets. There are also on this floor two parlours or withdrawing rooms —the whole forming a suite of six rooms, opening into each other by lofty folding doors, presenting vistas the whole length of the building. In the upper part are retiring-rooms, two spacious billiard-rooms, and accommodation for a housekeeper.

An Historical Account and Delineation of Aberdeen, Robert Wilson, 1822

The foundation stone of the Assembly Rooms was laid on 26 April 1820, with great Masonic gravity, by the Earl of Fife. The ceremony was preceded by a procession of 1,500 Masonic Brethren from the Town House. An 'immense concourse of people of all ranks crowded the streets, which were enlivened by the gay and elegant appearance of ladies – the windows, balconies, &c. in Union-Street, being literally a grand display of beauty and fashion'. Coins from the reign of George III, who had passed away in January 1820, were placed in holes in the foundation stone, which was covered by a plate with the inscription:

ABERDEEN PUBLIC ROOMS, BUILT BY SUBSCRIPTION. FOUNDED WITH MASONIC HONOURS, BY JAMES, EARL OF FIFE, — DEPUTE GRAND MASTER

FOR SCOTLAND, APRIL 26TH, 1820, FIRST YEAR OF THE REIGN OF GEORGE THE FOURTH. ARCHIBALD SIMPSON, ARCHITECT.

The Aberdeen Assembly Rooms, with its massive Ionic-columned portico frontage to Union Street, was completed in 1822 to a design by Archibald Simpson. The building, which included a ballroom, dining rooms and space for billiards, was intended as an appropriate setting for the Aberdeenshire elite to socialise in a grand manner. The description by Robert Wilson provides an impression of the opulence of the venue. In 1858, the building was sold to the Aberdeen Music Hall Company and a large concert hall designed by James Matthews was added. The building was taken into the ownership of the council in 1928 and was comprehensively refurbished from 1984 and reopened on 12 May 1986.

22. Golden Square and Duke of Gordon Statue

Golden Square was built between 1810 and 1821 as part of Charles Abercrombie's 'Further Improvements' for the city – a series of planned formal squares was originally proposed, but only Golden Square was built. The square consists of elegant two-storey granite town houses. The land was owned by the Incorporated Trade of Hammermen, one of the seven incorporated trades of the city, and the street names in the area – Diamond, Silver and Golden – reflect their work in precious metal and jewellery.

> The colossal statue (of the 5th Duke of Gordon) was cut by Messrs. McDonald and Leslie, after a model by Campbell, of London, from a block of granite brought from the Dancing Cairn Quarries, which weighed some 16 tons. It measures 11 feet 3 inches. The pedestal is of red granite; it stands 10 feet 3 inches, so that the height of the figure and pedestal is 21 feet 6 inches. The Duke is represented in military character, leaning gracefully on his sword, with his left foot resting on a broken mortar. Professor Traill says, in reference to this statue, on his visit to the works of Messrs. McDonald and Leslie: two men were at work on the drapery. They worked with fine chisels, held very obliquely, and urged on by iron mallets of two or three pounds in weight. This, which may be considered as the first specimen of a British statue of a single block of granite, in emulation of the durable monuments of ancient Egypt, is a memorial by the county to the late noble and gallant officer; and will be a distinguished ornamentation to Aberdeen.
>
> *The Illustrated London News*, 11 May 1844

The statue of the 5th Duke of Gordon in the centre of Golden Square was originally located in the Castlegate and was moved to the present site in 1952 to make way for street improvements. It was carved from a single monolithic piece of granite by the Aberdeen firm of Macdonald and Leslie, based on a model by the sculptor Thomas Campbell (1790–1858). Alexander MacDonald (1794–1860) was a pioneer in the Aberdeen granite trade. He developed equipment and practices to carve and polish granite that transformed the industry. The statue of the Duke of Gordon, which MacDonald's firm produced, was the first major granite statue since the days of the Ancient Egyptians.

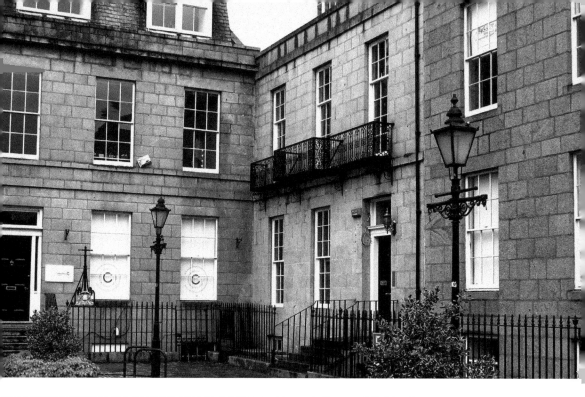

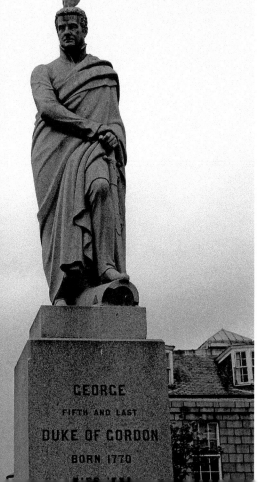

Above: A Corner of Golden Square.

Left: The Duke of Gordon statue.

GEORGE

FIFTH AND LAST

DUKE OF GORDON

BORN 1770

23. Former Triple Kirks, Schoolhill and Belmont Street

The tall graceful brick square tower and octagonal spire of the former Triple Kirks is a prominent landmark in the city centre. It was a feature of the unique Triple Kirks – three self-contained but adjacent churches with a shared steeple – the only church in Scotland which was purpose-built to house three separate congregations. The trio of church buildings was designed by Archibald Simpson and opened in 1844.

It is said that they were built in six weeks to meet the needs of the three new Free Church congregations. The complex of buildings was the size of a small cathedral and was known as 'the Cathedral of the Disruption'. The Disruption of the Church of Scotland on 18 May 1843 occurred when over 400 ministers formed the breakaway Free Church of Scotland. This followed a long-running dispute about the freedom of the church from state control and the appointment of ministers by landowner patrons rather than the congregation. The Disruption resulted in the need for many more churches for the new congregations. The congregations of the Triple Kirks were breakaways from the East and West Churches of St Nicholas and the South church.

Simpson seems to have been quite pleased with the result, as the building features in the background of his 1848 portrait by James Giles.

The churches fell in to disuse in the 1980s. The West Free has been completely demolished, some walls survive of the North Kirk and the East Free has been converted

The Former East Free Kirk.

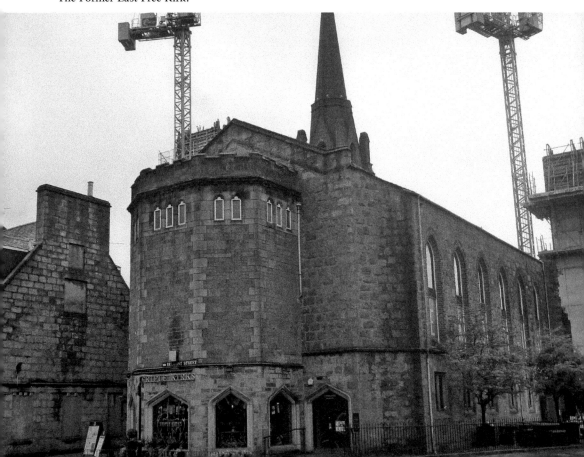

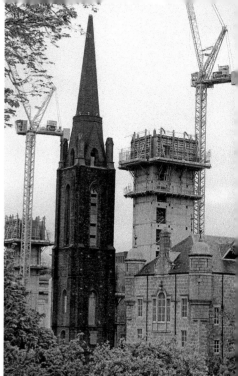

Above left: The Triple Kirks.

Above right: The Triple Kirk spire.

into commercial premises. Since the churches were disused there have been a number of proposals for the reuse of the site. At the time of writing, a development of student housing was being constructed with the spire retained.

24. Aberdeen War Memorial and the Cowdray Hall

Before the arrival of the Royal party, the Aberdeen War Memorial was solemnly dedicated. The proceedings attracted great public interest, and many thousands attended the dedication service, which was held in front of the new building in the open air. Special provision was made for ex-Servicemen and their relatives of whom a large body attended. Three men from each local military or naval unit attended to pay tribute to the fallen, while there were representatives from various organisations of ex-Servicemen. At two o' clock, led by the band of the 4th Gordon Highlanders, the company joined in singing the Psalm, *God is our refuge and our strength*. There was a short and impressive interval of silence, broken by the *Last Post*. Lord Provost Meff and the Magistrates, members of the town council and others entered the Hall of Memory. There, Mr Peter Tocher, an ex-Serviceman, who lost five sons in the War deposited The Roll of Honour, containing the names of over 5000 citizens of Aberdeen and district in a casket resting on the shrine.

Scotsman, 30 September 1925

The colonnaded crescent-shaped War Memorial at the western end of the Art Gallery was designed by Alexander Marshall MacKenzie in an appropriately austere neoclassical style. It

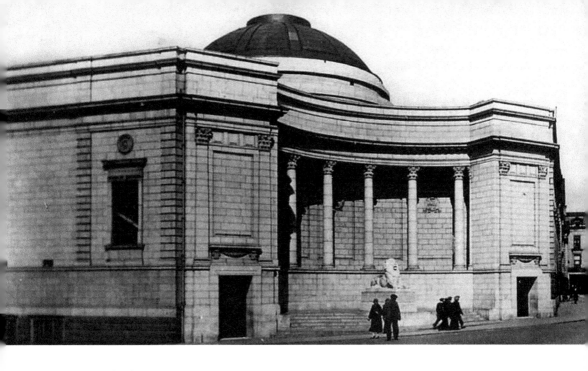

Above and below: The War Memorial.

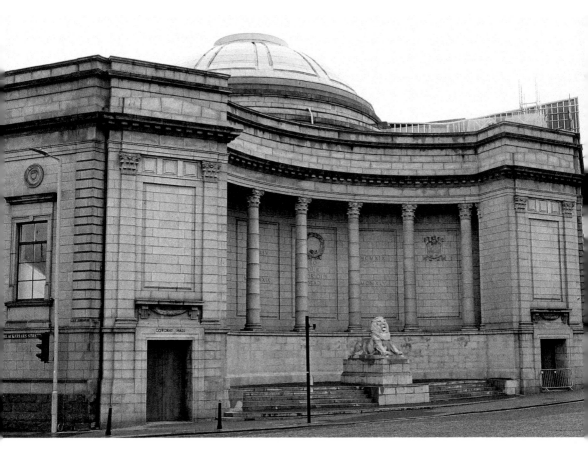

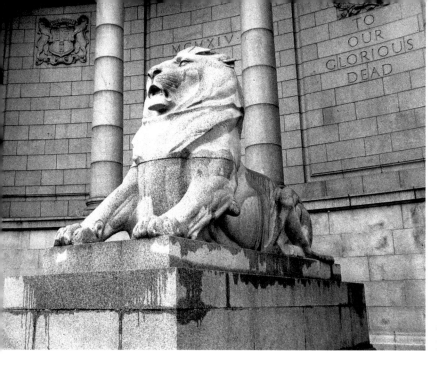

The War Memorial lion.

is inscribed 'To Our Glorious Dead' with a wreath of laurels and the city and county coats of arms. The War Memorial Hall inside the Cowdray Hall contains the books of remembrance. The dignified lion sculpture was designed by William MacMillan (1887–1927) and executed by Arthur Taylor. The site was originally intended as a setting for the fine memorial statue of Edward VII, which was positioned at the junction of Union Terrace and Union Street.

The War Memorial was unveiled by King George V and Queen Mary on 29 September 1925. Relatives of the fallen were given the opportunity to lay flowers on the memorial and seats were made available for 100 disabled ex-servicemen in front of Schoolhill Station. On the day, Viscountess Cowdray provided entertainment for 3,000 children in four large marquees in the grounds of Robert Gordon's College.

The Cowdray Hall was endowed by the Cowdray family. Weetman Dickson Pearson, Viscount Cowdray (1855–1927), was a prominent industrial engineer in the family firm S. Pearson & Son and a major benefactor to the city of Aberdeen. He died shortly before he and Lady Cowdray were due to be awarded the Freedom of Aberdeen at a ceremony in the Music Hall on 3 May 1927. The Cowdray Hall remains a popular venue.

25. Aberdeen Art Gallery and Former Gray's School of Art

Aberdeen Art Gallery and the former Gray's School of Art date from 1885 and form a continuous run of buildings along the north side of Schoolhill, linked by the arched entrance to Robert Gordon's College. They were designed by the prolific local architect Alexander Marshall Mackenzie in a Renaissance style and are finished in a distinctive two-colour treatment of bright white Kemnay granite with pink Corrennie granite detailing. The entrances to both buildings are framed by full-height Corinthian columns supporting dentilled pediments. The elegant sculpture court, modelled on the Palazzo Vecchio in Florence, was added by Mackenzie in 1905. It is top lit and the columns that form the colonnade are in a variety of different coloured granites.

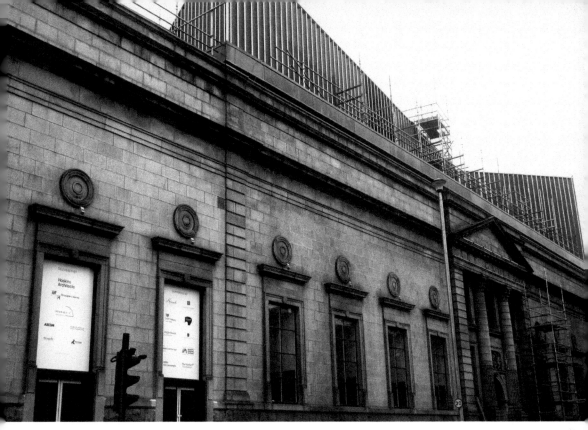

Aberdeen Art Gallery.

The Art School was founded as Gray's School of Science and Art by John Gray (1811–91) with the aim of supporting 'education in drawing, painting, modelling, and all branches of art'. Gray was a self-made man who had risen to become a partner in an Aberdeen firm of engineers and ironfounders. His interest in education was a result of the difficulties in obtaining adequate training that he had encountered as a young man. The school moved to a new building at Garthdee in 1965. The building is now used as offices for the university.

26. Robert Gordon's College, Schoolhill

Aberdeen born Robert Gordon (1668–1731) was a graduate of Marischal College who made a fortune working out of Gdańsk (Danzig) as a successful merchant trader. In 1720, he returned to Aberdeen and left his fortune for the establishment of 'a hospital for the maintenance, aliment and education of young boys'. Work on the building started in 1730, shortly before Gordon's death, and was completed by 1743. However, it did not open for its intended purpose until 1750 – it was used by the Hanoverian army from 1746 during the Jacobite rising.

The building is an outstanding example of eighteenth-century neoclassicism by William Adam, the foremost Scottish architect of the time and the father of Robert and James. It is known as the 'Auld Hoose' and is embellished with a statue of Robert Gordon over the entrance. The college buildings were comprehensively remodelled during the early nineteenth century by John Smith.

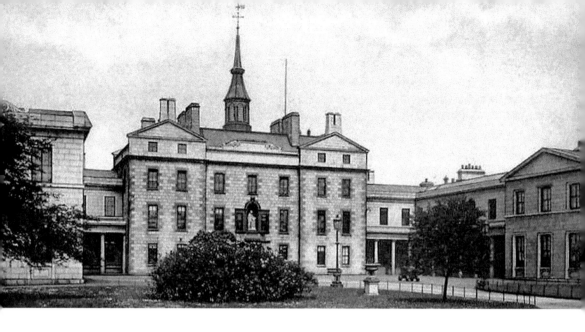

Above and below: Robert Gordon's.

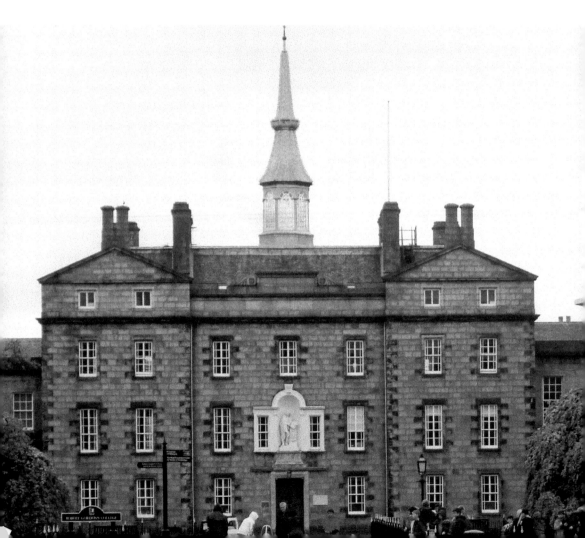

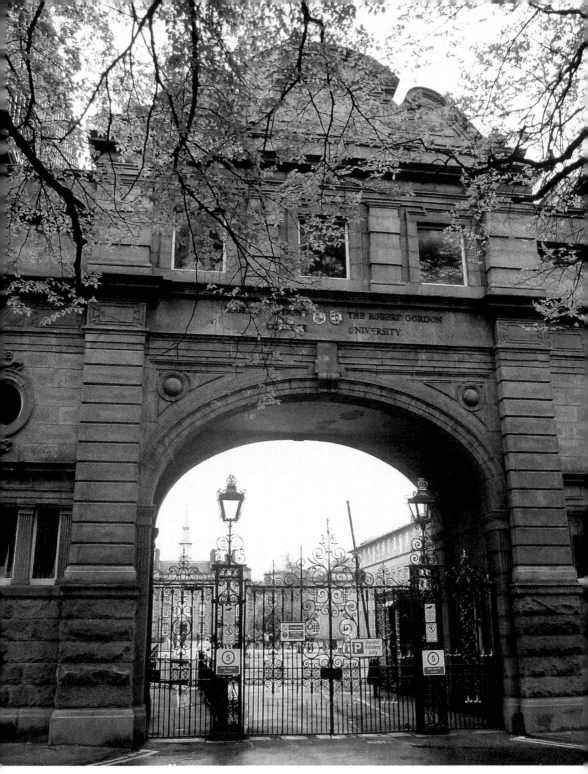

Robert Gordon's Gateway.

Robert Gordon's diversified in two directions in the nineteenth century – as a private school and a college, which became Robert Gordon's Technical College in 1910 and achieved university status in 1992.

27. Aberdeen Public Library, Rosemount Viaduct

The new public library was opened yesterday. The building is a handsome structure situated on the Rosemount Viaduct, on a site the view of which is commanded from Union Bridge. It has three principal rooms - the lending library, the reference library, and a public reading room. The architect was Mr Alexander Brown, Aberdeen, his design having been selected on competition. The buildings have cost about £10,000, and this sum was raised by public subscriptions, Mr Andrew Carnegie, of Pittsburgh, USA, being the largest individual subscriber, having contributed a £1,000. In respect of this contribution, Mr Carnegie was presented with the Freedom of the City, the ceremony taking place in the Council Chamber, Lord Provost Stewart presiding.

Press and Journal, 6 July 1892

Aberdeen's imposing new library was opened by Andrew Carnegie on 5 July 1892. At the opening ceremony Carnegie noted that 'after comparing all the uses to which surplus

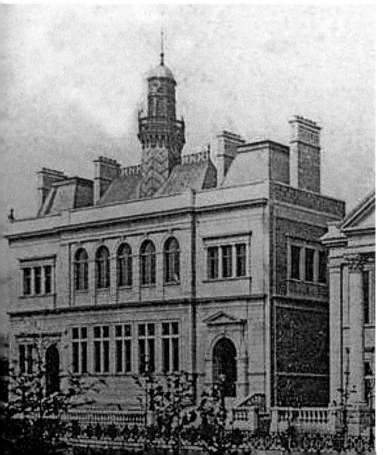

Aberdeen Public Library.

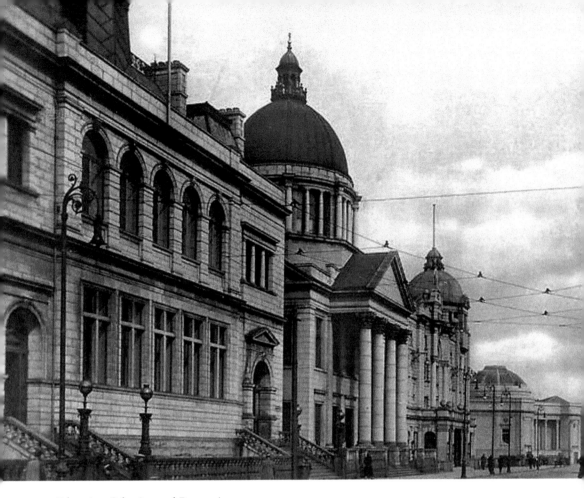

Education, Salvation and Damnation.

wealth could be put, I have been led to the conclusion that the greatest and best use of all is
to devote to the building of free public libraries for communities which evince a willingness
to maintain them'. In 1884, there were only eighty-four official free libraries in Britain,
which rose to 400 by the end of the nineteenth century. Much of the growth was due to the
generosity of Carnegie, 'whose faith in libraries for the people as agencies for good was so
strong'.

The new library featured noiseless cork carpeting and a reading room with a table
reserved for ladies only.

The library, along with its neighbours His Majesty's Theatre and St Mark's Church,
'form the most distinguished grouping of major buildings in Aberdeen'. They are known
locally as Education, Salvation and Damnation.

28. St Mark's Church, Rosemount Viaduct

Church architecture has become so much associated in one's mind with tall spires and
Gothic windows, that there is difficulty on the part of many people of the old school
in reconciling themselves to any departure from that idea. There is no reason, however,

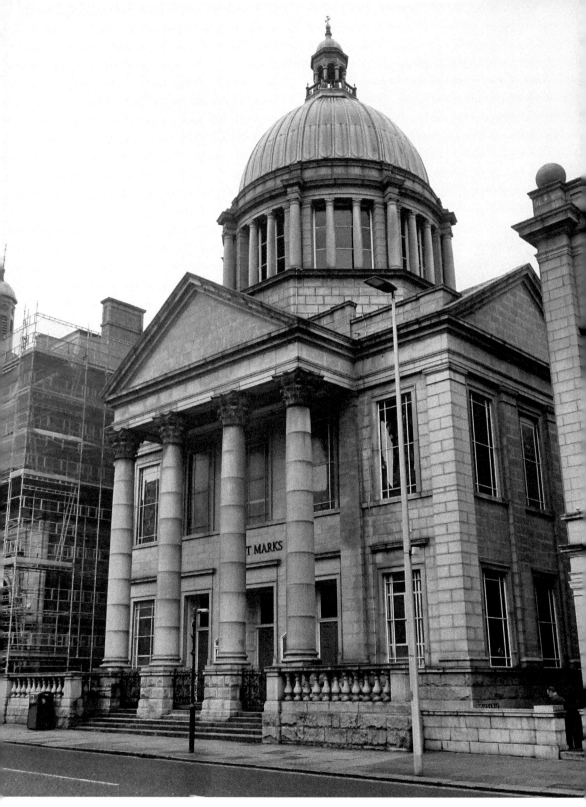

St Mark's Church.

why there should not be varieties in ecclesiastical architecture as well as in other public buildings, and the new Free South Church in Aberdeen, which is just undergoing the finishing touches, and will be opened on the Sabbath next for public worship, affords a welcome change in its external aspect from the general style of such buildings. In place of the lofty spire, there is a spacious dome; and instead of lancet windows, there are square windows. As now finished, the building is a decided acquisition to the architectural features of the city; it is a step forward in church architecture; and will fulfil in an eminent degree all the purposes for which it was intended. Occupying on the Viaduct a position which renders it conspicuous from the main thoroughfares of the city, its most obvious and striking features are the Doric dome, the finial of which is 150 feet from the level of the street; and the four graceful granite columns, with their clear cut pure Corinthian capitals, which support the pediment. The dome itself internally is 28 feet in diameter and will be used for choir practising or such purposes.

The Aberdeen Weekly Journal, 16 March 1892

St Mark's, with its giant Corinthian portico surmounted by a dome modelled on St Paul's Cathedral, is one of Aberdeen's finest church buildings. It was completed in 1892 for the congregation of Aberdeen's South Parish and was originally known as the Free South Church. The elegant classical design was by Alexander Marshall Mackenzie.

29. His Majesty's Theatre, Rosemount Viaduct

Aberdeen has for many years been in a chronic state of grumbling over its theatre. It can now have no excuse for even a whisper of discontent. His Majesty's Theatre, which opened last night in presence of a brilliant audience that filled every inch of accommodation in the huge building, is as up-to-date in every detail as any theatre in the country.

The Aberdeen Daily Journal, 4 December 1906

Aberdeen's His Majesty's Theatre opened on 3 December 1906 with a run of the pantomime *Little Red Riding Hood*. The performance was advertised as featuring special scenery, new and elaborate costumes, a chorus of forty trained voices, a children's ballet, the Poppyland troupe of dancers, and all the popular songs of the day. To mark the occasion, each member of the audience was presented with a special souvenir booklet, *The Playhouses of Bon-Accord* by J. Malcolm Bulloch, dramatic critic of the *Sphere*, which included records of the Aberdeen theatres past and present. The first performance in the new theatre was enthusiastically received by the opening-night audience and it was described as a 'happy hit'.

The new theatre was designed by the celebrated theatre architect Frank Matcham (1854–1920) – 'Matchless Matcham'. Matcham completed his first theatre design in 1879 and went on to create hundreds of unique venues throughout the country in the heyday of British theatre construction. Matcham never formally qualified as an architect, learning his profession by apprenticeship and experience. His theatres are notable for their stylish and subtly luxurious interiors, and eclectic mix of architectural

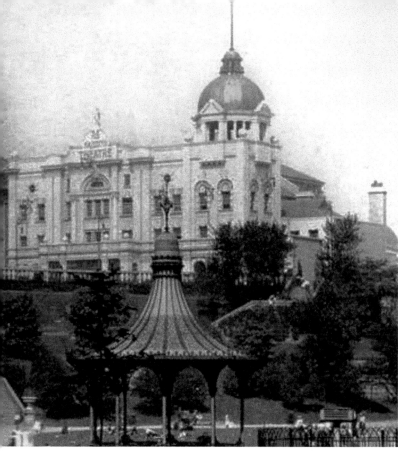

Left: His Majesty's
Theatre.

Below: His Majesty's
Theatre today.

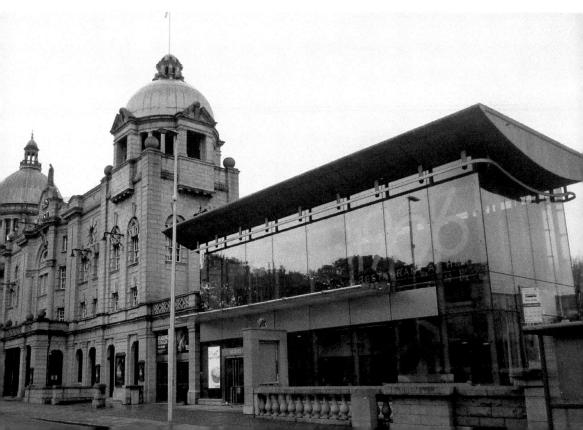

styles. He also established new innovative principles in providing clear sightlines and improved safety standards.

At His Majesty's, Matcham created an immensely impressive venue to host the very best in show business of the time. The exuberant frontage incorporates a stylish mix of architectural features, which is matched by a lavishly decorated interior. The theatre was named after King Edward VII, to contrast with the earlier Her Majesty's Theatre on Guild Street. Convenient trains were run by the Great North of Scotland Railway to the Schoolhill station for the performances.

The theatre was a major touring venue and hosted many of the very best-known performers. The first proprietors were the Robert Arthur Theatre Company. The venue was bought in 1933 by James F. Donald, a local businessman, who refurbished the theatre and introduced features such as external neon lighting, a cinema projector and a revolving stage – at its time, the only one in Scotland. It was taken into the ownership of the local authority in 1975, closed for refurbishment in 1980, was reopened by HRH the Prince of Wales on 17 September 1982 and was further modernised and extended in 2005 with a new glass-fronted box office, café and restaurant.

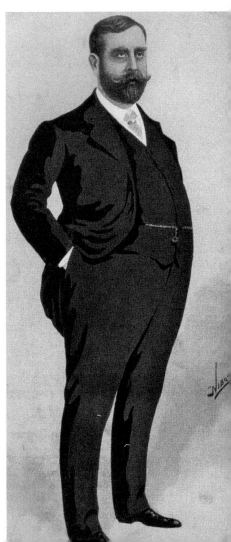

Above: A game of giant draughts in Union Terrace Gardens.

Right: Frank Matcham.

The older image of the theatre shows a view looking over Union Terrace Gardens, which were first opened in 1889 in the valley of the Denburn. There have been a number of recent controversial proposals for the development of the gardens.

30. Wallace Statue, Rosemount Viaduct

The statue represents Wallace as standing on a rock; the figure being firmly poised on the right leg, and the left foot, well advanced, planted on a raised projection. The head is bared, the hair being blown back as if by a fresh breeze, and the animated expression of the features corresponds with the action of the outstretched left arm in emphasising the declaration, which the champion is supposed to be making to the English Ambassadors, that his purpose is not to treat, but to fight for Scotland's freedom. The right hand holds the huge sword, whose blade, forming a diagonal line across the body, seems to bar the enemy's advances. In the absence of any authentic portrait, the head is partly ideal, formed on the description of the hero's appearance. The costume, which has been studied from carved work of the period, consists of chain armour under a tunic which is girt around the middle by the sword belt. A cloak falling from the shoulders, and partly covering the left arm, affords opportunities for effective disposition of light and shade.

The Scotsman, 7 November 1884

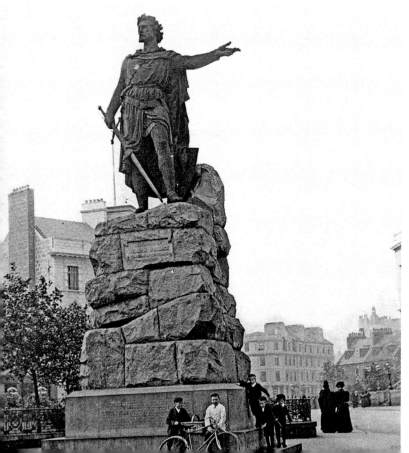

Wallace statue.

The huge bronze statue of Wallace stands 5 metres (16 feet) high on a massive 5.1-metre-high (17-foot) pedestal of roughly cut Corrennie granite. It was unveiled by the Marquis of Lorne at 3 p.m. on a 'dull but dry day' on 29 June 1888 amidst great cheers and the band playing *Scots Wha Hae*. The streets were crowded with spectators, flags fluttered from various points, and the city was noted as presenting 'quite a holiday aspect'. The Marquis was first granted the Freedom of the City at the Town House. The ceremony concluded at 4 p.m. with the national anthem, and cheers for Lord Lorne and the Queen.

The design of the statue was the result of an international competition. Twenty-five sculptors from the United Kingdom, France, Germany and Italy had submitted entries. The result of the competition was announced in November 1884. The trustees for the statue, with advice from Sir Noel Paton RSA and Dr Rowand Anderson, selected the design by Mr William Grant Stevenson (1849–1919). The design of the statue was fairly well known prior to its unveiling, as a plaster cast of the statue had been exhibited at the Edinburgh International Exhibition of 1886.

Mr John Steill of Edinburgh, who passed away in 1871, had an abiding interest in the history of Scotland and left a legacy of over £3,000 to meet the cost of the statue. In his letter of instruction of 13 March 1866, he stated that he had 'from boyhood cherished an admiration of the character of William Wallace, the deliverer of Scotland from English thraldom, and the heroic martyr of the liberties of his country'. He desired to leave some

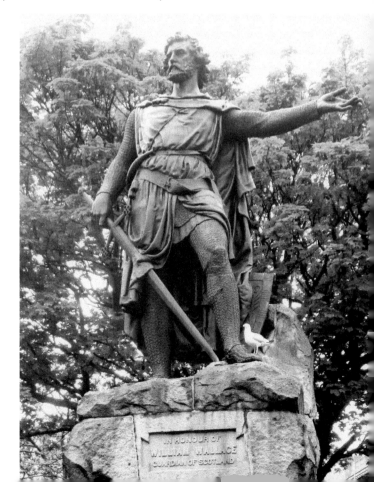

Wallace statue today.

token of his love for the memory of the great man, and of his attachment to the principles for which Wallace contended. He directed that the statue should be constructed to be massive and bold in detail representing an embodiment of the natural and unadorned genius of the statesman and warrior. The statue is inscribed, 'I tell you a truth, liberty is the best of all things, my son, never live under any slavish bond.'

The statue was originally proposed for a site in Duthie Park, which was never viewed favourably by many of the people of Aberdeen. The City of Aberdeen Extension and Improvement Act of 1883 proposed the construction of a new road across the Denburn Valley as a westwards extension to Schoolhill with a spur connecting the new street to Union Terrace. The triangular space that was created by these new streets was finally selected as the site for the Wallace statue.

31. Tenement Block, Rosemount Viaduct/Skene Street

The Rosemount and Denburn viaducts were designed by William Boulton and opened in 1886. They spanned valleys to join Rosemount to Schoolhill and allowed new areas to be opened up for development to accommodate a significant increase in the population of the city.

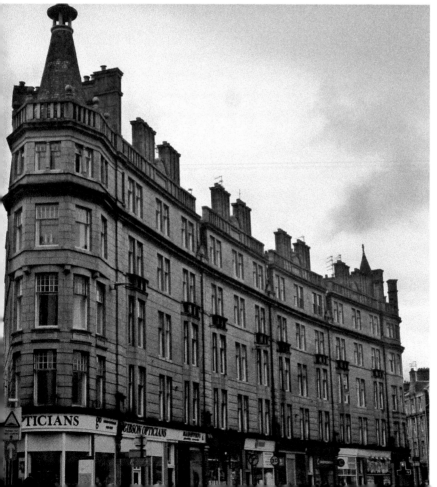

Tenement Block, Rosemount Viaduct/Skene Street.

The substantial flatted block at the corner of Rosemount Viaduct and Skene Street, designed by A. Brown & G. Watt for the Aberdeen Town and Country Property Company in 1897, with its stack of bay windows and turret roof, is one of the best examples of tenement development in the city.

32. Former Woolmanhill Hospital

The first Aberdeen general hospital, designed by William Christall, was opened in 1741 at Woolmanhill. In 1838, this was demolished to make way for a fine new neoclassical building, the Simpson Pavilion, designed by Archibald Simpson. In 1892, the building was converted into a nurses' home on completion of the new hospital, the Jubilee Extension Scheme, to the north of the earlier building. The Simpson Pavilion is a rare surviving example of an early nineteenth-century hospital building, the design of which was overtaken from the 1860s by the introduction of Nightingale wards, in which the functions of the hospital were separated into different buildings. The new Aberdeen Royal Infirmary was opened at Foresterhill in 1936. At the time of writing, the old hospital building at Woolmanhill was in a neglected condition and awaiting refurbishment.

Former Woolmanhill Hospital.

33. Former Broadford Works, Maberly Street

The Broadford Works was founded in 1808 by Scott Brown and Co. in the traditional textile manufacturing district of Aberdeen. In 1811, the business was sold to Sir John Maberly (1770–1839), who introduced jute to the UK, developed innovative manufacturing processes and rapidly expanded the Broadford Works – Maberly Street is named in his honour. Maberly was declared bankrupt in 1832 and the works were sold to John Baker Richards & Co., which developed it into a flax business specialising in sail canvas, fire hoses and similar products. The company was one of the largest employers in Aberdeen. A total of 3,000 millhands worked in the business at its peak, and it was one of the few to survive the mid-nineteenth-century decline of Aberdeen's textile

Broadford Works, Bastille Building.

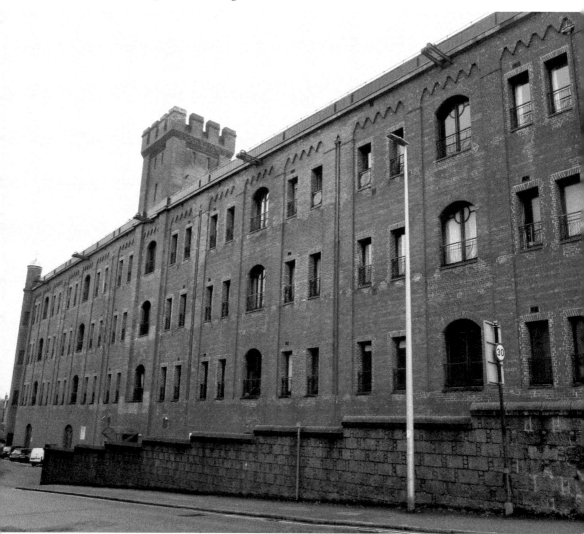

Plan of the Broadford Works, 1898.

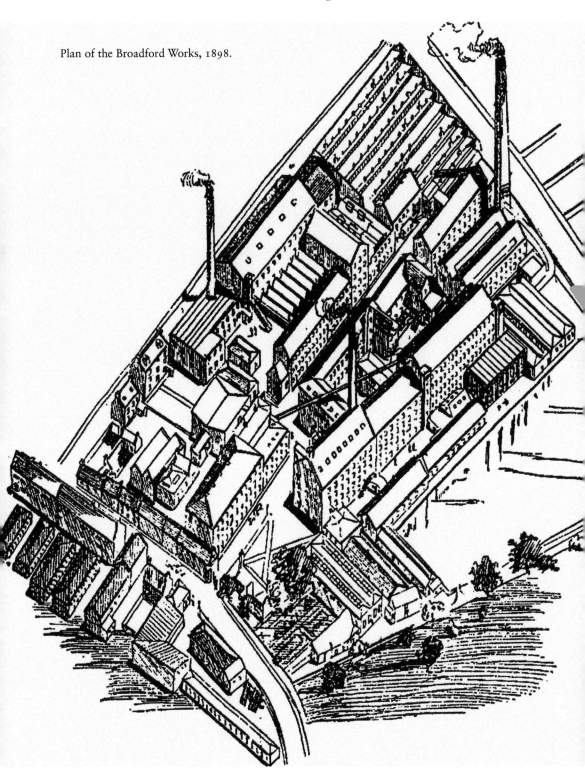

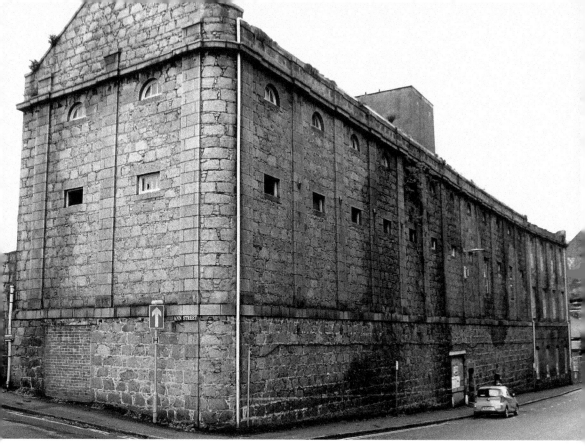

Broadford Works, Hackling Building.

industry. The business finally closed in 2004 and the buildings are being considered for refurbishment.

The former Broadford Works comprises a large group of buildings, including the oldest iron-framed mill in Scotland. The massive four-storey brick block with Baronial detailing on the south side of Maberly Street is a former flax warehouse dating from 1912 – it is known as the 'Bastille' and is the largest brick building in Aberdeen. It was converted into flats in 1995.

34. Rosemount Square

Rosemount Square was designed by Leo Durnin of the City Architects Department in 1938, but construction was delayed by the Second World War and it was not completed until 1948. It is an elegant elliptical wall of tenements in an art deco style with three arched pends providing access to a sweeping curved courtyard, from which there is access to the tenement stairs. Rosemount Square was the last all-granite tenement to be built in Aberdeen. Granite would have been an expensive choice of material at the time and its use reflects the aspirations to create a building of the highest quality. The notable stylised bas-relief sculptures, representing wind and rain, above the entrance pends are by renowned sculptor Thomas Bayliss Huxley-Jones (1908–68). The quality of the development was recognised by a Saltire Award in 1948.

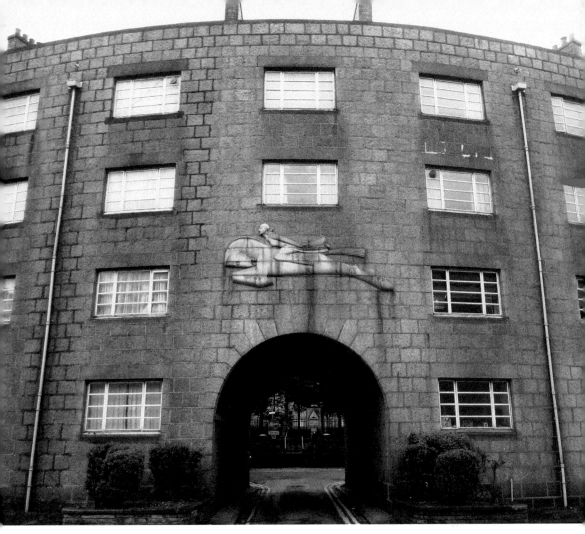

Above: Rosemount Square.

Below: Rosemount Square sculpture detail.

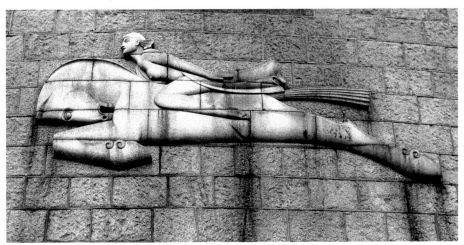

35. Aberdeen Grammar School and Byron Statue, Skene Street and Esslemont Avenue

This is a neat modern building forming three sides of a square, and having a belfry in the centre of the main building. It contains a public hall, and four teaching rooms all on one floor. The teaching rooms have lately been enlarged by two additional wings at the back of the building. In ancient times, the grammar-school consisted of detached buildings, situated near the site of the present structure. The accommodation, however, was very inconvenient and uncomfortable; therefore the magistrates erected the present building in the year 1757, with part of the funds which Dr Dunn had left to be applied solely to the maintenance of the masters. The school stands on part of the ground which formerly belonged to the Dominican Friars, and is situated in that part of the town which is denominated the Schoolhill.

An Historical Account and Delineation of Aberdeen, Robert Wilson, 1822

Aberdeen Grammar School was founded in the thirteenth century and originally occupied successive buildings on Schoolhill, near the entrance to Robert Gordon's College. The new grammar school on Skene Street/Esslemont Avenue opened on 23 October 1863. It was designed by James Matthews in a Baronial style.

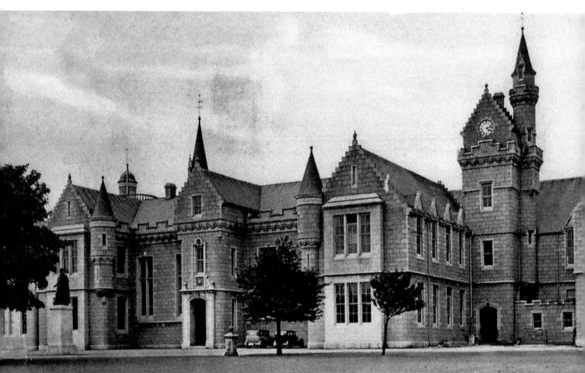

The Grammar School.

In its original form, it was a private school for boys with a curriculum restricted to the classical languages and ancient history – 'ornamental subjects like arithmetic and writing were assigned to private specialists in extra-mural institutions, these being considered beneath the dignity of a Grammar School'. The subjects taught were expanded with the construction of the new school. It became a comprehensive in 1970 and co-educational in 1973. In 1986, the school was damaged by a fire with the loss of important items from the library including a collection of Byron's notebooks. The restoration took a number of years to complete.

It is not generally remembered that Lord Byron, the most world-famous of English poets, since Shakespeare, was through his mother, a Gordon and a Scot, and that his early life was passed at Aberdeen, which provided his first school. It is natural that Aberdeen should honour his memory and in the middle of September there will be a great unveiling ceremony of a fine statue in the Granite City.

The Sphere, 18 August 1923

It is the privilege of genius to transcend common experience, and to Byron, the title can scarcely be denied. Local interest in the poet has received considerable stimulus this week

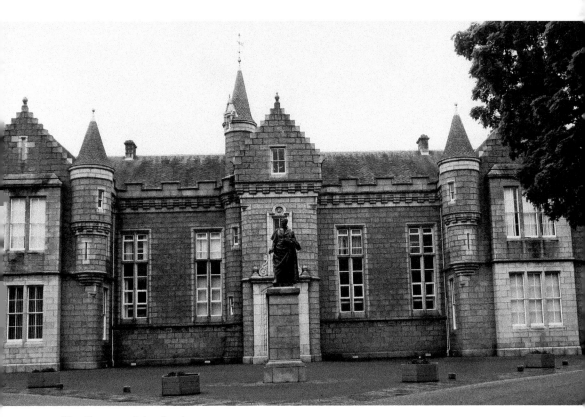

The Grammar School today.

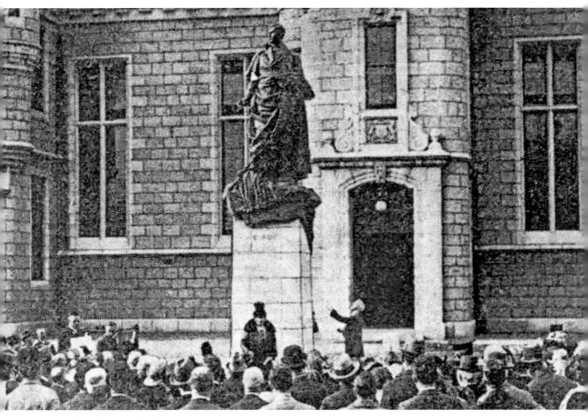

Unveiling of the Byron statue.

by the erection of his statue in the Grammar School grounds. Even if it be allowed that their atmosphere, 130 years ago, was more Arcadian than it is now, lodging in Queen Street and Virginia Street, followed by a longer residence in the more aristocratic quarter of Broad Street, scarcely provided the environment one would select for the rearing of a romantic young rebel, who resided in the town with his mother from 1790 to 1798. At the age of five he was sent to a school in the salubrious quarter of Longacre, kept by a fussy old gentleman called *Bodsy Bowers*, where all he learned was to say by rote, *God made man: let us love him.* On his disastrous record there becoming known, he was promoted to a school in Drum's Lane. In January, 1795, at the age of seven he entered the first class of the Grammar School.

Press and Journal, 15 September 1923

Lord Byron attended an earlier version of the grammar school as a young boy in the 1790s and is its most renowned former pupil. A bronze statue of Byron has pride of place in front of the school. It was the work of the Sculptor Royal for Scotland James Pittendrigh MacGillivray (1856–1938), and was unveiled by the Marchioness of Huntly in September 1923. The address on Byron was given by Professor Grierson of Edinburgh University, who presented the statue to the school.

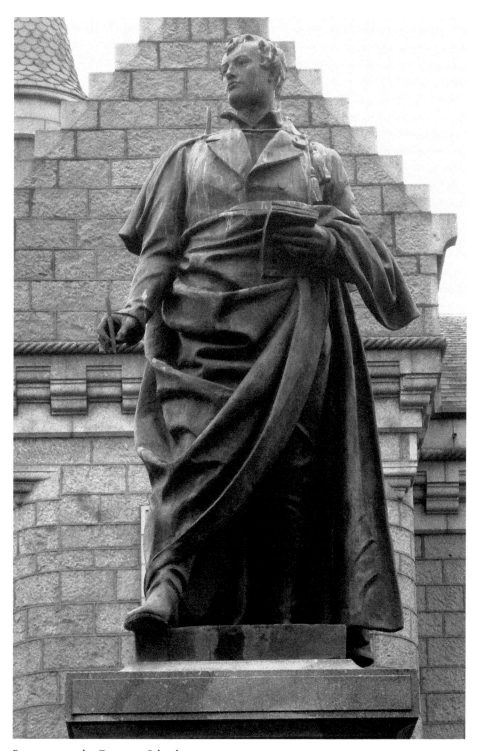

Byron statue, the Grammar School.

36. Former Christ's College, Alford Place

The former Christ's College with its Gothic tower, buttresses, Tudor arched windows and door, oriel window, leaded glass, crenellations, and pinnacles forms a picturesque termination to the west end of Union Street. The building dates from 1850 and was built as a college to train ministers for the Free Church of Scotland. It is now a bar and restaurant.

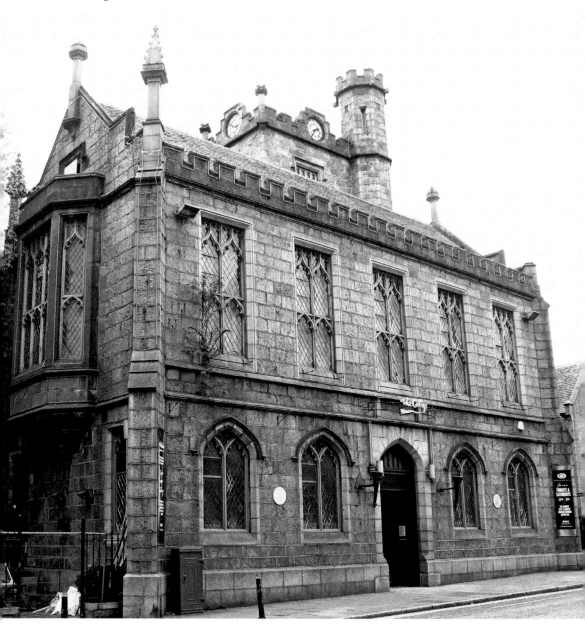

Christ's College.

37. Bon Accord Baths, Justice Mill Lane

Aberdeen Town Councillors yesterday inspected the plans for the new up-town baths to be erected at Justice Mill at an estimated cost of £70,000. The plans show a pond 120 feet in length by 42 feet in width, with depths varying from three feet to seven feet and a diving pool 15 feet deep. There is terracing capable of providing accommodation for 1,000 spectators seated, and there are 168 dressing cubicles, with 468 lockers for clothes and other belongings. The granite façade of the building is without ornamentation. The entrance hall faces Justice Mill Lane, and on either side of the corridor leading to the pond hall at the rear are eighty slipper baths, while in the front portion of the building are baths for men and women, Turkish and medicinal bath suites, a sun-ray treatment room, and a club room.

Scotsman, 19 August 1936

The art deco Bon Accord Baths were designed by Alexander McRobbie of the City Architect's Department and opened in August 1940. The intention was to provide a centrally located public baths as an alternative to those at the beach. In addition to the swimming pool, the baths provided private bathing facilities – a much-needed public service at a time when many homes did not have bathrooms. The pool was also used for swimming shows, which were part of summer season leisure activities in the city.

The building is an exceptional example of an interwar public baths with an austere symmetrical cubist façade. The interior is more opulently detailed with an exceptional semicircular vaulted roof over the pool area, which allows natural light to flood the space.

Bon Accord Baths.

The baths were closed by the council in March 2008 due to financial cutbacks. A number of proposals have since been considered for the reuse of the building and there has been a long-running campaign to restore the baths.

38. Queen's Cross UF Church, Carden Place and Albyn Place

Queen's Cross Church was built to serve the expanding population in the westwards expansion of the city. The competition for its design was won by John Bridgeford Pirie, of Pirie and Clyne. The church opened for worship on 17 April 1881. The outstanding building with its soaring 46 metres (150 feet) high steeple, eclectic mixture of architectural styles and idiosyncratic detailing occupies a prominent corner site at Queen's Cross.

The statue of Queen Victoria in the foreground of the image was originally located at the corner of St Nicholas Street and Union Street in 1893, where it was a popular meeting place. It was moved to Queen's Cross in 1964.

Queen's Cross Church.

39. Hamilton Place Villas

74 Hamilton Place, Aberdeen. This attractive self-contained dwelling house in first-class order throughout is for sale by private bargain with early occupation. Accommodation: 2-3 public rooms, 4-5 bedrooms, bathroom, kitchen, scullery, ample pantry and linen cupboards, attractive garden with greenhouse and outhouses, telephone. Feu duty - £5 10 shillings.

Press and Journal, 6 October 1944

Hamilton Place Villas.

Aberdeen's westwards expansion in the second half of the nineteenth century resulted in the construction of a number of substantial villas. These reflected the prosperity of the city and the new-found wealth of many Aberdonians. A group of highly original mainly double-fronted villas on Hamilton Place, by local architects John Bridgeford Pirie (1851–92) and Arthur Clyne (1853–1924), dating from the mid-1880s, are among the best examples from this period. Commissioned by local builder John Morgan, they combine eclectic styles and idiosyncratic detailing.

40. The Maggie's Centre

The strikingly contemporary Aberdeen Maggie's Centre sits in open parkland at the Aberdeen Royal Infirmary's Foresterhill campus. The elegant concrete sculptural form of the building was the work of Oslo-based architects Snøhetta.

It is named the Elizabeth Montgomerie Building in memory of the golfer Colin Montgomerie's mother – Montgomerie spearheaded the fundraising campaign, which raised £3 million in donations. The building was opened by HRH Sonja, Queen of Norway, and Maggie's President, HRH the Duchess of Rothesay, on 23 September 2013.

The Maggie's Centres, which are named for Maggie Keswick Jencks, who died of cancer in 1995, provide welcoming environments for the support of people with cancer. They are known for their innovative design by world-famous architects.

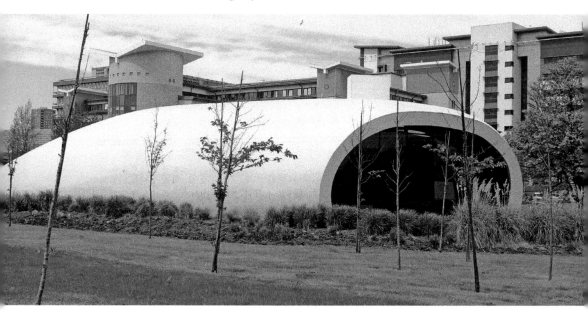

The Maggie's Centre.

41. Footdee (Fittie)

Footdee, or Fittie, as it is known locally, was laid out in 1808–09 by the then Superintendent of the Town's Public Works, John Smith. The new village was a replacement for the original Footdee, which was located further north-west and was home to Aberdeen's local fishing community. The site of the original village was redeveloped as part of Thomas Telford's

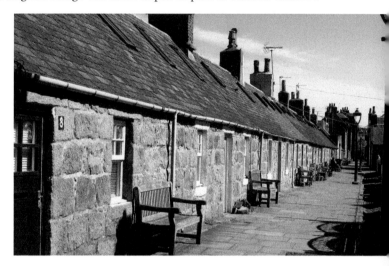

Right: Footdee (Fittie).

Below: Footdee (Fittie), Tarry Sheds.

harbour improvements. The new Footdee is unusual in being a planned fishing community. The solidly built cottages provided superior accommodation to the conditions in the original village. In 1880, the town council started to sell the houses and individual owners stamped their own identity on the formal layout with a series of random changes including the addition of 'tarry sheds' for the storage of fishing equipment on the communal land. The present owners of the picturesque cottages maintain the maritime theme of the area with the display of a range of seafaring paraphernalia.

42. Marine Operations Centre Harbour Masters' Tower, Pocra Quay

The award-winning Marine Operations Centre at Aberdeen Harbour opened in February 2006 and was designed by SMC Parr Architects (Archial). It succeeded the Navigation Control Centre (the Roundhouse), which dated from 1803. With its interlocking curved glass and streamlined concrete design, the new building forms a major landmark at the entrance to the harbour. It is used to control all ship movements at the harbour.

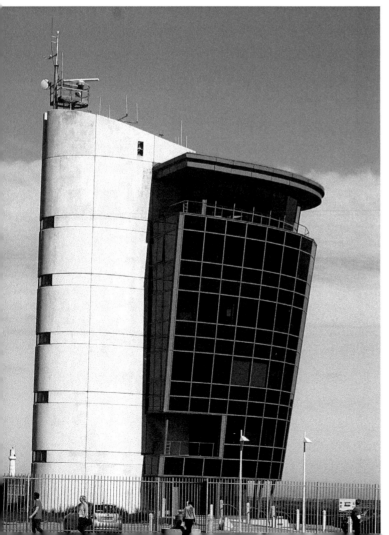

The Marine Operations Centre.

43. Torry Point Battery

The Torry Point Battery stands on rising ground on the north side of Torry Point, overlooking the southern approaches to the River Dee and the harbour entrance. Aberdeen's importance as a port meant that it was subject to potential attack over the centuries. The Torry Battery replaced a number of earlier defensive structures. The first was a lookout and warning beacon on the south side of the harbour and a chain barrier, which dated from the early sixteenth century. An artillery blockhouse on the north side of the harbour was first established in the 1490s and was rebuilt on several occasions.

The Torry Battery was built from 1859 and was completed by March 1861, with the aim of defending the city and harbour from the danger of a French invasion. In its original form, the battery was roughly diamond shaped with a range of buildings protected by defensive bastions and a high granite curtain wall.

It was originally manned by the 1st Aberdeenshire Royal Garrison Artillery (Volunteers) and armed with nine heavy guns. The battery was fully operational throughout the First and Second World Wars. The guns were fired only once when two ships approaching the harbour on the night of 3 June 1941 failed to identify themselves – they were later found to be friendly. Later in 1941, a German aircraft was machine gunned from the battery. It was also used as accommodation for homeless families after both wars.

The guns were removed in 1956 and the buildings partially demolished. The extant parts of the battery – the perimeter wall, gateway, guardhouse and gun mounts – have been protected as a Scheduled Ancient Monument since 2004. The battery is now a popular site for bird and dolphin watching.

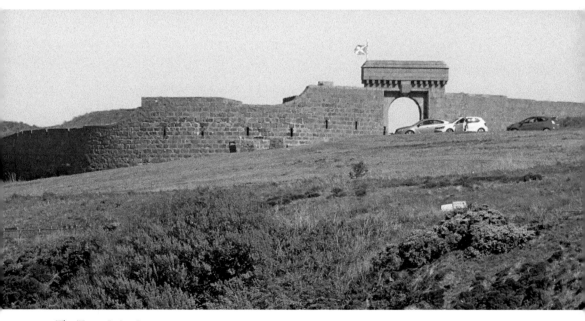

The Torry Point Battery.

44. Girdleness Lighthouse, Greyhope Road

Melachony Loss of the Whale-Fishing Ship, Oscar. On Thursday last, after a tract of the mildest weather known for many years, one of the most sudden and violent storms was experienced and was attended with one of the most melancholy and distressing events that ever happened at this place. In the morning the wind veered to the south-eastward, with snow blowing strong. At this time five of the whale-fishing ships belonging to this port - the Hercules, Latona, Middleton, St Andrew and Oscar which had sailed early in the morning, were riding at anchor in the bay. A boat from the Oscar having gone ashore for some of the crew stood into the bay and succeeded in getting the last of her hands on board. Soon after which, the great violence of the gale which commenced from the north-east, with thick snow, rendered her situation perilous in the extreme, and filled the people on the shore with the most painful apprehensions. About half past eleven o' clock AM, the Oscar was seen to go ashore in the Grey Hope, near the Short Ness. The heart-rending scene which now presented itself, made it too apparent that all human efforts for the preservation of the unfortunate ship and crew would be unavailing. The vessel lay among large rocks, and from the tremendous sea which went over her, was already breaking up. At this time, an attempt was made by the crew, to form a sort of bridge to the nearest rocks by cutting away the main mast, which unfortunately fell alongside the ship, instead of towards the shore as they had so fondly expected. Many of the men who had clung to the rigging, were now plunged into the sea, by the falling of the fore and mizzen masts, and disappeared into the merciless ocean; and most of the remainder having nothing to hold by, were swept of the wreck, and sunk in sight of those on shore, who could render them no assistance, although the distance between them and the unfortunate seamen was such to admit of a communication of sentiment, even of countenance. The fate of several others seemed no less hard, for after having nearly gained the shore, they were swept off by the heavy surf, or borne down by the casks and other wreck with which they were surrounded. The forecastle of the Oscar still remaining above water, five men were observed, and among them Captain Innes was distinctly seen making signals for that assistance which could not possibly be afforded; and after clinging long to the wreck and struggling hard for life, they shared the fate of their unfortunate companions, the vessel having soon gone to pieces. About this time, Mr John Jamson, 1st mate, and James Venus, a seaman belonging to Shields, were with difficulty saved, being the only survivors of the sad catastrophe, out of a crew of 44. Thus perished the Oscar, which, but a few hours before, had sailed with the fairest prospect, and being very complete in all her equipments, might be valued at £10,000; and thus was lost, one of the finest crews which could go to sea, men who so lately set out full of hope and expectation, and were in one fatal hour cut off, many of them leaving, by their untimely fate, their widows and numerous families in that anguish and distress, towards the alleviation of which, we trust a generous and benevolent public will contribute in this trying period.

Press and Journal, 7 April 1813

The nature of the wrecking of the *Oscar*, with the loss of so many lives, on 1 April 1813 was not a direct result of the absence of a light; it was also reported that the crew of the *Oscar* were drunk and incapable of handling the ship at the time of the disaster. However, the

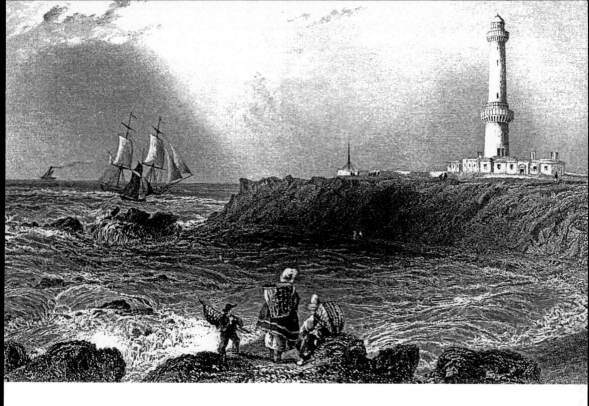

Above and below: Girdle Ness Lighthouse.

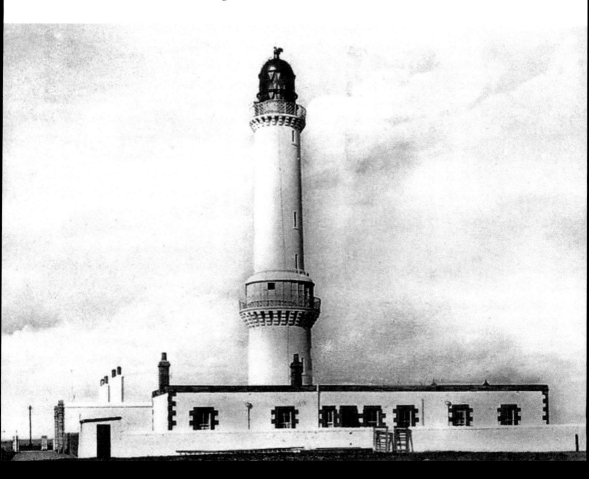

tragedy emphasised the dangers of the approach to the harbour and resulted in increased calls for the establishment of a lighthouse at Girdle Ness.

The new lighthouse, on the headland to the south of Aberdeen harbour, was designed by the renowned lighthouse engineer Robert Stevenson (1772–1850), grandfather of Robert Louis Stevenson, for the Northern Lighthouse Board. It was built by Aberdeen contractor John Gibb and became operational on 15 October 1833.

It is a striking circular-section tapering white tower with a minaret-like silhouette 37 metres (121 feet) in height. Keepers' cottages and other associated buildings are clustered around the base.

The lighthouse originally incorporated innovative fixed twin lights. The lower light, which was in a glazed gallery around 11 metres (36 feet) from the base, was removed in 1890. The main light was replaced in 1847, with the old lantern transferred to Inchkeith Lighthouse. Illumination was originally by vegetable oil burners, but these were later replaced by paraffin lamps. Today, the light has a range of 25 nautical miles.

The lighthouse was described by Sir George Airy (1801–92), the Astronomer Royal, as the best lighthouse that he had ever seen. The lighthouse was an essential factor in the continued growth of Aberdeen by making the dangerous approach to the harbour safer, and it is said that 'the city's debt to the lighthouse is too great to be calculable'.

The light was automated in 1991 and is controlled from the Northern Lighthouse Board's control room in Edinburgh.

In the 1880s, the lighthouse was augmented by a foghorn which was known locally as the 'Torry Coo' due to the sound it made resembling the mooing of a cow – although a very noisy cow, as it could be heard 20 miles away in calm weather. The foghorn has been disused since 1987.

45. The Beach Ballroomw

Far from satisfied with the fame it has already achieved - through its well planned and well built city of granite, through its commercial success, through its fishing fleets, and through its manufacture of humorous stories - Aberdeen is advancing once more along a new path in search of renown as a popular holiday resort. First and foremost in the long list of holiday benefits, with which Aberdeen hopes to draw increasingly heavy tourist traffic, is the broad bay with its curving sweep of golden sands. A three mile promenade, terraced and furnished with numerous seats and shelters, runs along the whole length of the beach. For the crowds that throng this stretch of shore in July and August an up-to-date pleasure park has now been provided, with a pleasantly exciting scenic railway.

When the midsummer moon is shining over the sands of Aberdeen, there will be many who will linger late in the evening to watch the breakers on the shore and the twinkling lights of distant lighthouses; but for those who want to wind up a day in the open with some hours of indoor joy, there are two centres at the beach which cater fully for their desires. One is the variety entertainment pavilion, a building of comfort and elegance, where an exceptionally good concert party hold the stage. The other is the magnificent new dance hall, built of sparkling white granite and decorated inside with striking effectiveness and good taste. Erected at a cost of £40,000 to hold 1,500 persons, this circular ballroom,

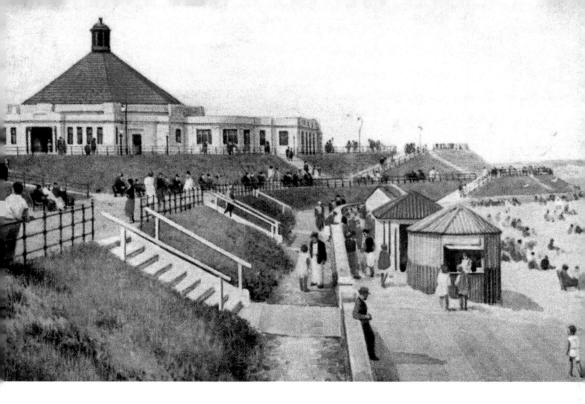

Above and below: The Beach Ballroom.

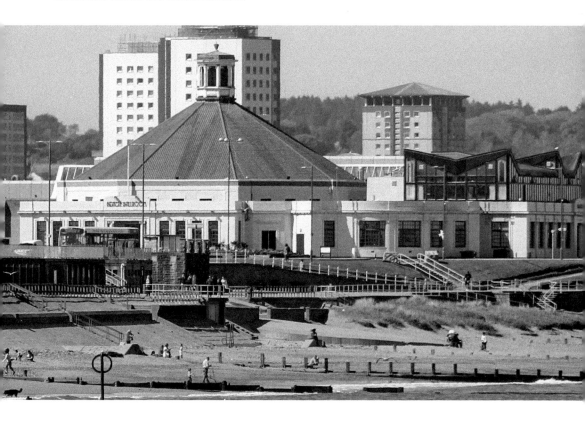

with its commodious balcony, brilliant lighting effects and coloured fountain, is an achievement of which Aberdeen should be justly proud. The astonishingly cheap charges, both in the ballroom and the commodious café attached to it, will undoubtedly make it one of the main magnets of the holiday season in Aberdeen.

Scotsman, 18 June 1929

Aberdeen's Beach Ballroom officially opened on 3 May 1929 with a lavish masked ball and carnival. It was built as part of a beach improvement scheme by Aberdeen Town Council to encourage visitors to the city. The art deco design, octagonal shape and red tiled roof make it a distinctive feature of the seafront. The ballroom floor, which is supported by 1,400 steel springs, is famed for its bounce. Apart from a period during the Second World War when the building was used by the military, it has been in constant use as an entertainment venue.

46. Town House, Old Aberdeen

Old Aberdeen, on the banks of the River Don, was a separate burgh until its amalgamation with Aberdeen in 1891. The town developed around St Machar's Cathedral and King's College on the route from Aberdeen to the Brig o' Balgownie. It retains much of its original character, street pattern and core of historic buildings.

The gracefully proportioned Town House with its central pediment, square clock tower embellished with urns, and octagonal belfry overlooks the marketplace and is a distinctive feature of Old Aberdeen. The building dates from 1788 and is attributed to George Jaffrey. It was built on the site of an earlier tolbooth.

The stone panel above the main entrance depicts the burgh arms of Old Aberdeen, featuring the Aulton Lily, which was previously abundant in the area, and the burgh motto

Old Aberdeen.

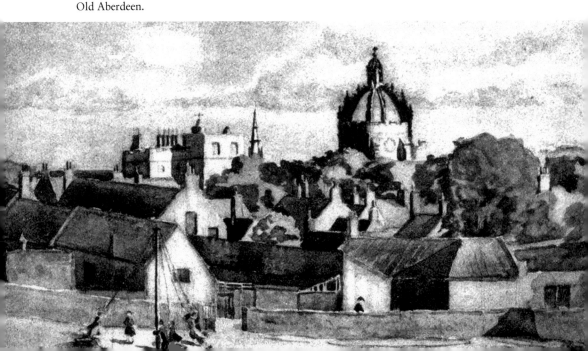

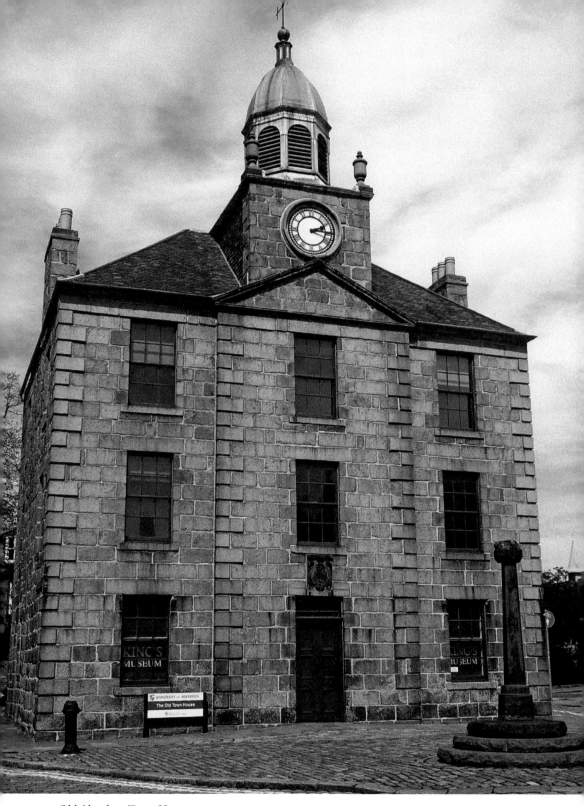

Old Aberdeen Town House.

Concordia res parvae crescunt (By harmony small things increase). The panel and the dormer pediment with the royal arms built into the east wall were reused from the older tolbooth on the site.

The building was the hub of Old Aberdeen. It has been used as the burgh's administrative centre, a merchants' and tradesmen's hall, a jail, a public library, for social events and as a school. The building is the emblem of the Architectural Heritage Society of Scotland.

47. King's College Chapel

King's College was founded in 1495 by William Elphinstone, the Bishop of Aberdeen, following the issue of a papal bull by Pope Alexander VI and was named for King James IV, its main patron. It was the first university in Aberdeen and the third in Scotland. The chapel was built from 1498 and was consecrated in 1509. It is the central hub of the college and forms the north side of the university quadrangle. Its crown spire is a symbol of the university and the splendid interior is one of the most complete medieval church spaces in Scotland.

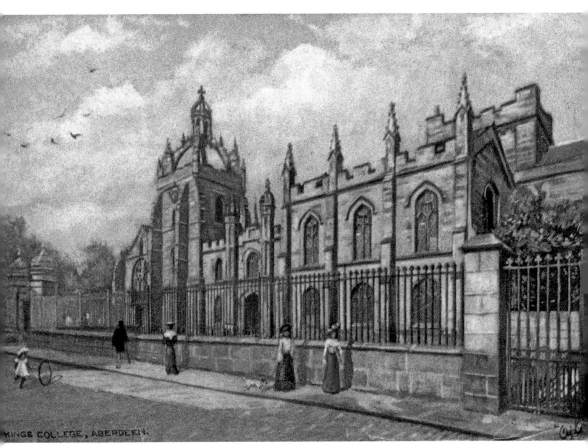

King's College.

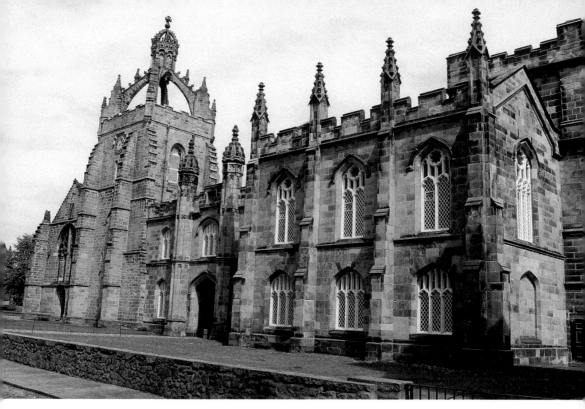

King's College.

48. St Machar's Church, The Channory

St Machar was a sixth-century saint who came to Scotland as a follower of St Columba. He is said to have founded a place of worship on the site of the present church in 580.

In the twelfth century, a Norman cathedral was built on the site. In the latter part of the thirteenth century work started on a replacement building, which was seriously damaged in 1336 during the Wars of Independence. Work continued in more peaceful times and, by 1530, the church had been significantly enlarged and ornamented. In 1560, the church lost its status as a cathedral, at the time of the Scottish Reformation. The building was looted and became the local parish Presbyterian kirk.

In 1654, Cromwell's troops plundered the derelict bishop's palace and the choir of the church for building stone. In 1688, the central tower collapsed in a storm and damaged other parts of the church. Worship was restricted to part of the nave and it took until 1953 to restore the damaged east end.

The panelled ceiling of the nave, which dates from first half of the sixteenth century, is decorated with forty-eight heraldic shields of Scottish archbishops, bishops and European royalty. The early literary figure John Barbour (*c.* 1320–95), author of *The Brus*, was Archdeacon of the Kirk of St Machar and is commemorated by a memorial in the church. There is a legend that William Wallace's left arm was interred in the walls of St Machar's following his gruesome execution and the dismemberment of his body by the English in 1305.

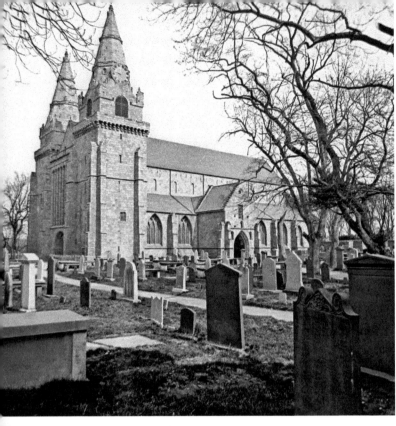

Left: St Machar's Church.

Below: St Machar's Church today.

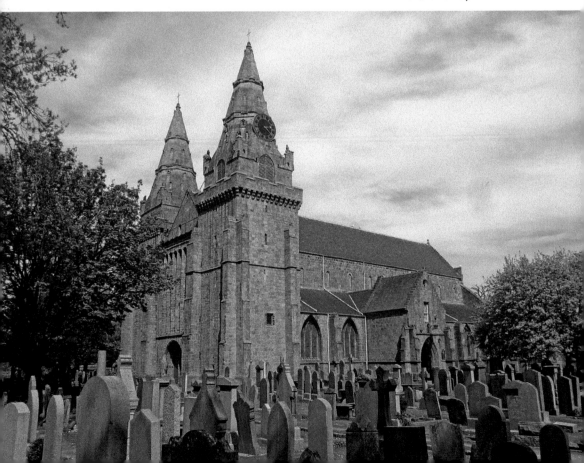

49. The Sir Duncan Rice Library, Aberdeen University Library

The exterior of Aberdeen University's Sir Duncan Rice Library is a strikingly modern eight-storey cube of serrated strips of white and clear glass. The strictly geometric form of the exterior stands in sharp contrast with the organic contours of the full-height interior atrium.

The building was designed by the Danish architects Schmidt Hammer Lassen in an international design competition and was formally opened by The Queen on 24 September 2012. It is named for Professor Sir Charles Duncan Rice, who was principal of the university from 1996 until 2010. The building has won numerous awards, including a Royal Institute of British Architects National Award in 2013.

The Sir Duncan Rice Library interior.

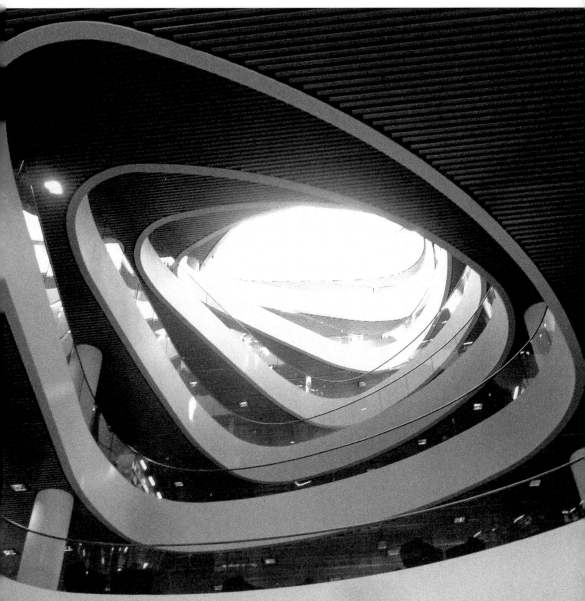

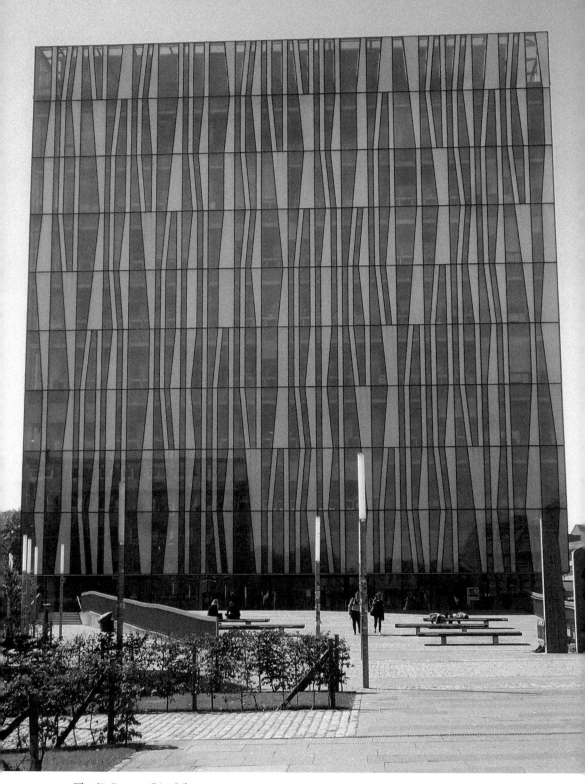

The Sir Duncan Rice Library.

50. The Brig o' Balgownie

Oft have I near Balgownie's brig. Plucked hawthorn spray and hazel sprig. The Brig o' Balgownie or, as it is now more commonly called, the Brig o' Don, is a Gothic arch of great antiquity, and, in a very interesting and picturesque neighbourhood, bestrides the river from rock to rock, about half a mile above its junction with the German ocean. This is the same brig to which Lord Byron so fondly alludes in *Don Juan*, and, perhaps I may be pardoned for inserting here the line and the note annexed to it - *As Auld Langsyne brings Scotland, one and all, Scotch plaids, Scotch snoods, the blue hills, and clear streams, The Dee, the Don, Balgownie's Brig's black wall, All my boy feelings, all my gentler dreams*. The Brig of Don near the auld town of Aberdeen, with its one arch, and its black deep salmon stream below, is in my memory as yesterday—I still remember, though perhaps I may misquote the awful proverb which made me pause to cross it, and yet lean over it with a childish delight, being an only son, at least by the mother's side. The saying as recollected by me, was this, but I have never heard or seen it since I was nine years of age: Brig of Balgownie, black's your wa'/Wi' a wife's ae son, and a mear's ae foal/Down ye shall fa.

Mayflowers, John Imlah, 1827

The Brig o' Balgownie over the River Don dates from the late thirteenth century and was strategically important for many years as the only route from Aberdeen to the north. It is said to be the oldest bridge in Scotland.

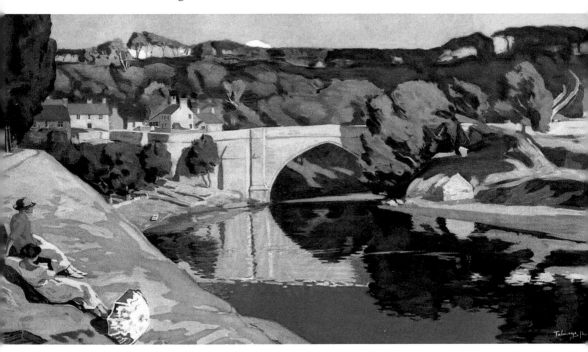

The Brig o' Balgownie.

The bridge was reputedly commissioned by either Bishop Henry Cheyne or Robert the Bruce, and was the work of Richard Cementarius (Richard the Mason), who has some claim to being the first provost of Aberdeen and was master mason to King Alexander III of Scotland.

The bridge was rebuilt at the start of the seventeenth century and has been repaired many times since. It consists of a single elegant pointed Gothic arch with a span of 12 metres (67 feet) and a narrow carriageway of 3 metres (10 feet).

It was known as the Bridge of Don until 1830, when it was bypassed by the new bridge.

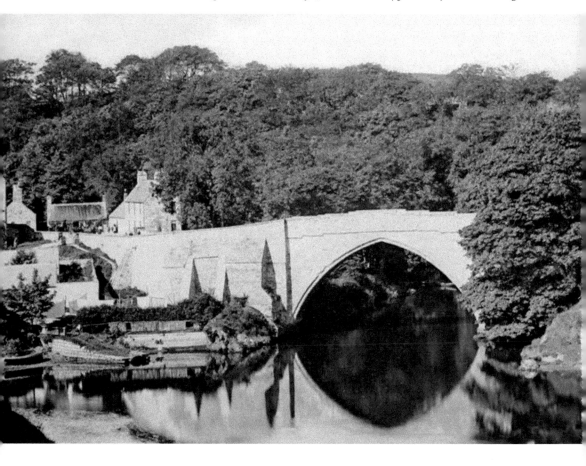